iPhone Artistry

iPhone Artistry

Dan Burkholder

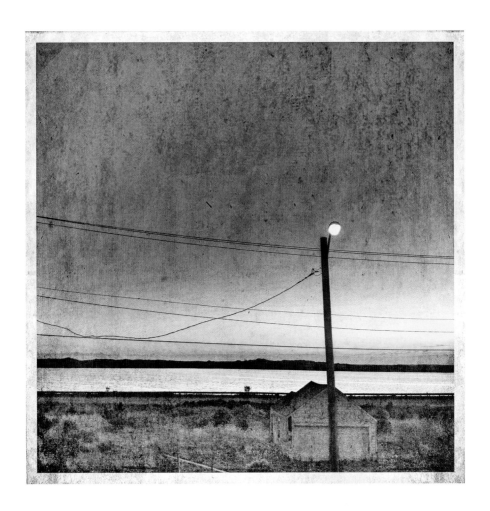

An Imprint of Sterling Publishing Co., Inc.
New York

Editor: Kara Arndt
Book Design: Tom Metcalf
Cover Design: Thom Gaines

Library of Congress Cataloging-in-Publication Data

Burkholder, Dan, 1950-
 iPhone artistry / Dan Burkholder. -- 1st ed.
 p. cm.
 Includes index.
 Summary: "There's no doubting how popular the iPhone is, or how impressive its imaging capabilities are--both with photos and video.
That's why it's now the most popular camera on Flickr. iPhone Artistry shows users how their phone can be a powerful, fun, and serious
photographic tool, with techniques for getting the highest-quality images, using their hardware to the fullest, and experimenting with a
multitude of the most creative apps available from the Apple store."-- Provided by publisher.
 ISBN 978-1-4547-0127-9 (pbk.)
 1. iPhone (Smartphone)--Handbooks, manuals, etc. 2. Photography, Artistic--Handbooks, manuals, etc. 3. Photography--Digital
techniques--Handbooks, manuals, etc. 4. Image processing--Digital techniques--Handbooks, manuals, etc. I. Title.
 TR263.I64B87 2011
 777.0285--dc23

 2011030509

10 9 8 7 6 5 4 3 2 1

First Edition

Published by Pixiq, A Division of
Sterling Publishing Co., Inc.
387 Park Avenue South, New York, N.Y. 10016

Text © 2012 Dan Burkholder
Photography © 2012 Dan Burkholder unless otherwise specified

Distributed in Canada by Sterling Publishing,
c/o Canadian Manda Group, 165 Dufferin Street
Toronto, Ontario, Canada M6K 3H6

Distributed in the United Kingdom by GMC Distribution Services,
Castle Place, 166 High Street, Lewes, East Sussex, England BN7 1XU

Distributed in Australia by Capricorn Link (Australia) Pty Ltd.,
P.O. Box 704, Windsor, NSW 2756 Australia

If you have questions or comments about this book, please contact:
Lark Books
67 Broadway
Asheville, NC 28801
(828) 253-0467
www.pixiq.com

Manufactured in Canada

ISBN 13: 978-1-4547-0127-9

For information about custom editions, special sales, premium and corporate purchases, please contact Sterling Special Sales Department
at 800-805-5489 or specialsales@sterlingpublishing.com.

For information about desk and examination copies available to college and university professors, requests must be submitted to
academic@larkbooks.com. Our complete policy can be found at www.larkcrafts.com.

For more information about digital photography, visit www.pixiq.com.

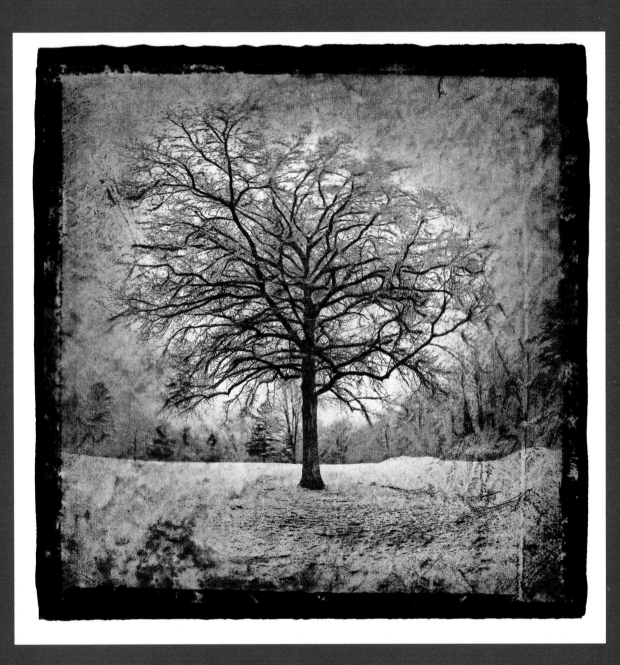

contents

Introduction

It's tempting to begin this book by discussing the first cell phone camera, but let's take a different tack on the subject. Why? Because, let's face it: Everything changed when Apple introduced their first iPhone in 2007. Suddenly there was a gadget that incorporated a phone, Internet access, a sleek user interface and—perhaps most importantly for photographers, a camera—all into one device that made it not just possible, but actually fun and engaging, to take pictures and share them. Now you could take a picture of your newborn and broadcast it to family and friends on the spot. Witness a breaking news event? You'd have it instantly on the airwaves.

My own cell phone camera saga began in 2005. With its camera and Internet access, the Sprint Treo 600 was a rudimentary introduction (by today's standards) to the thrill of sharing images with my wife and others. The camera was weak, unless confetti-like noise was your idea of good imaging. Viewing photos on the 160 x 160 pixel LCD display was no thrill either. No matter what care was taken when shooting, the image was a pixelated facsimile of the reality I tried to photograph.

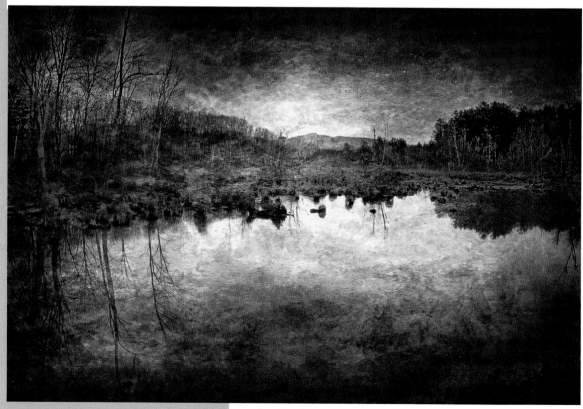

Wetlands and Distant Catskills

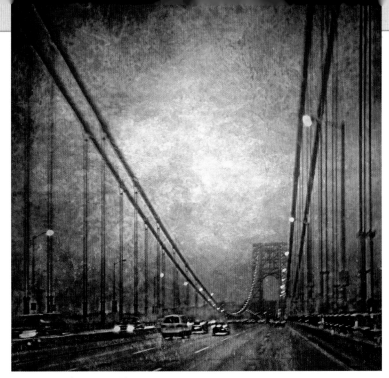

George Washington Bridge in Rain

As uninspiring as that initial experience was, it was clear that photography was changing in major ways. There was no way to guess how rapidly the cell phone camera would mature, but some things were obvious. More people than ever would have a camera with them at all times. Gone would be the gap between the moment of capture and the experience of sharing. And finally, making photographs would be as natural as talking on the phone.

Now smartphones—phones that combine basic voice communication with address book, calendar, Internet, and camera—dominate cell phone sales. In fact, odds are you're either a current iPhone user or are about to become one (a safe bet since you're reading this). But unlike my meager beginnings in this cell phone-camera era, right now you are standing at the edge of one of photography's great transitions: The ability to make a still image, a video image, a straight image, a manipulated image, a color image, a black-and-white image—whatever it is you want to do with a camera—is right in your pocket or purse.

In the following pages you'll learn how to use iPhone hardware and software to make images that will astound you, your friends, and your colleagues. You'll certainly learn the basics of iPhone photography but, after that, you'll get in–depth lessons on how to take your iPhone images into the realm of fine art. With control over the composition, tonality, color, and retouching (not to mention all sorts of image enhancement techniques), your iPhone images will stand proudly among your finest photographic achievements.

So grab your iPhone and let's get to work. Notice I didn't say, "Now sit down at your computer," because now that you're an iPhone photographer, anywhere is your studio and digital workstation. Now how can you not love that?!

Dan Burkholder

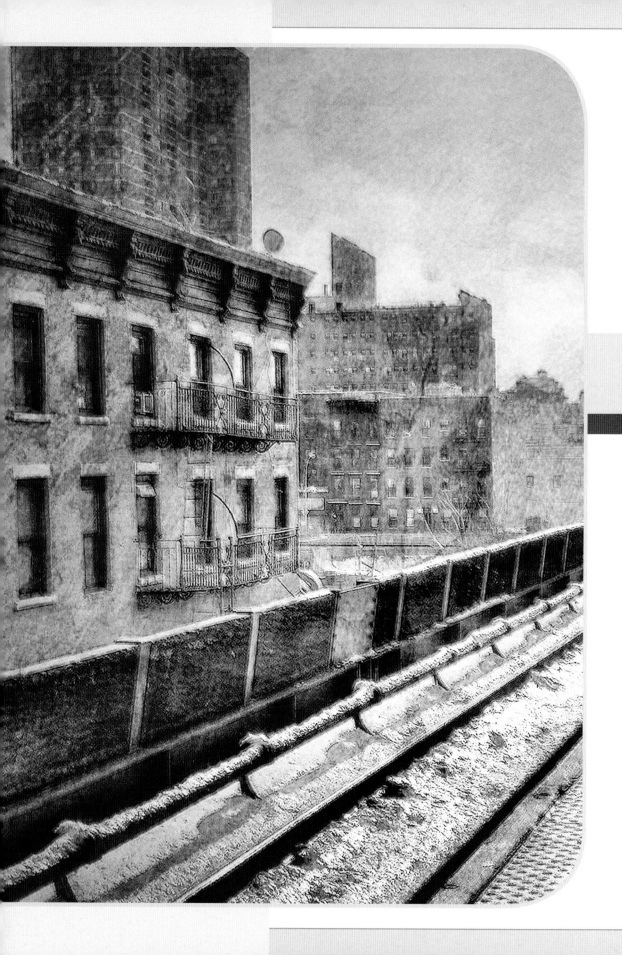

When Apple introduced the first iPhone in 2007, the world of personal communications shook to its foundation. Apple took the lead in making a smartphone where all the pieces fit together in an elegant, tiny, workable package.

Chapter ① iPhone Hardware

● A PHONE FOR PHOTOGS

With viable resolution (a moving target as the years advance), a "real" glass lens, and enough flash storage to make extended shooting possible, Apple morphed the cell phone camera into an object for serious photographers. But more than a combination of pixels, glass, and memory, the iPhone's real power came from the Wild West world of apps, where private developers found ways to extend the iPhone's photographic capability from the arena of image capture into image enhancement and stylizing.

Let's take a look, from the perspective of a photographer, at the iPhone's hardware, from that first iPhone—affectionately called the "Silverback" owing to its metallic case—to Apple's newest model, the iPhone 4S.

iPHONE SPECS

Camera Resolution: More resolution certainly seems like a good thing, but as we've seen all too often, some manufacturers try to fool us by jamming too many pixels onto too small of a sensor. Apple has methodically increased the iPhone's resolution, from the original iPhone and the 3G (2 megapixel (MP) camera) to the 3GS (3MP) to the iPhone 4 (5MP) to the iPhone 4S (8MP). Were Nikon or Canon to make similar strides, it would be like increasing their sensor resolution from 8MP to 32MP in three years' time in the same camera model. Even if nothing else in the iPhones had been improved, the camera improvements alone have been enough to keep many photographers on the upgrade bandwagon.

Close-Up Capability: As Apple has improved the iPhone, one of the most striking enhancements is the ability to focus. The 3GS was the first iPhone model to be blessed with the feature and the change was stunning (see 1.1). With its fixed focus lens, the 3G couldn't sharply render objects closer than about a foot from the lens. The 3GS includes a touch-to-focus feature that allows the user to change focus to the foreground flowers by touching that area on the LCD screen. As you can see, the 3GS produces a sharp foreground flower group and even introduces a bit of bokeh (the soft, out-of-focus effect) to the background flowers. The iPhone 4 has similar touch to focus and renders an image similar—but not identical, as you'll soon see—to that of the 3GS. With the newest iPhone 4S, much of the camera's behavior remains unchanged. The angle of view remains the same as the iPhone 4 at about a 28mm lens equivalent. The aperture has been increased to f2.4, and an updated sensor makes the 4S about one stop more sensitive, so its low light performance is even better. If you're familiar with the iPhone 4, you might notice a bit less depth of field owing to the 4S's slightly longer focal length.

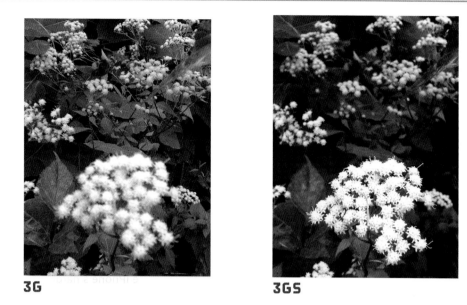

3G **3GS**

1.1 *Close-ups with iPhone 3G, 3GS, and iPhone 4*

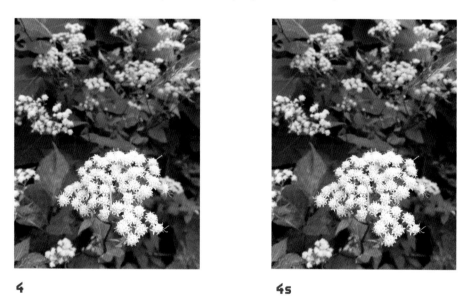

4 **4s**

Exposure Differences: Sharp-eyed readers might look at the four images in **1.1** and question the density and contrast differences. Let's talk about the 3GS image first. It's darker than the 3G shot, and here's why: When I used the touch-to-focus feature, the 3GS not only focused on the flowers closest to the camera, but also biased exposure for that region, too. This behavior is much like using a sophisticated DSLR's spot metering capabilities while selecting a focus area in the camera's viewfinder – as you move the focus area around, the camera meters on whatever spot is selected. When I focused on the foreground flowers, their bright luminosity caused the 3GS to underexpose. The 3G's fixed focus lens apparently employs an averaging type meter that, in this case, produced a better overall exposure than the 3GS. For the iPhone 4, I must admit that I cheated: I used the built-in high dynamic range (HDR) capability to capture better highlight and shadow detail (more about that on page 71).

3G

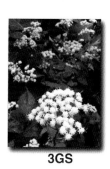

3GS

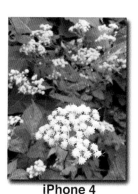

iPhone 4

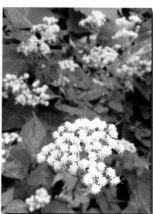

iPhone 4S

iPhone Artistry

The iOS5 operating system lets you lock focus and exposure on any part of your subject by tapping and holding for a second on the LCD. Pre-iOS5 iPhones (with focusing lenses) will focus and measure exposure where you tap, but if you recompose your shot, the focus and exposure areas will relocate automatically.

Resolution Differences: We can talk about how the iPhone models vary in resolution, but let's do more than recite pixel dimensions; you can look at the table on page 136 for that. Let's instead look at how image sizes actually compare, especially how they compare in terms of print sizes. **1.2** shows the relative print sizes from the different iPhone models (the original Silverback has the same resolution as the 3G).

CONTROLLING EXPOSURE

In our "real" cameras, we control exposure in a variety of ways, including shutter speed, aperture, ISO, and neutral density (ND) filters. (Studio photographers would argue that we can vary the amount of light on the subject, too.) All iPhone models have a fixed aperture, which essentially eliminates one exposure control that could come in handy. Assuming we aren't going to affix filters to the iPhone's lens, that leaves us with two ways of controlling exposure: shutter speed and ISO. The iPhone automatically varies the shutter speed and ISO to produce as close to a proper exposure as possible.

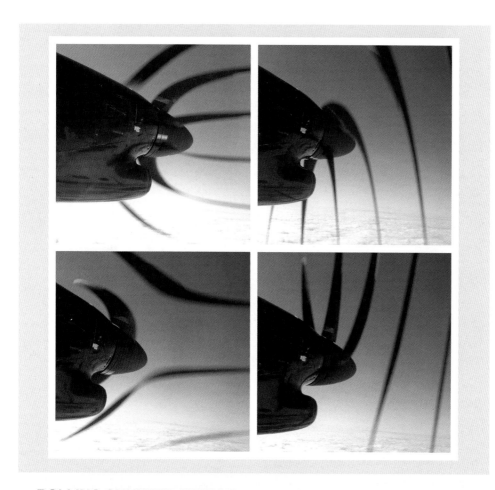

ROLLING SHUTTER EFFECT

These four exposures taken from the cabin of a commuter plane show a bizarre rendering of the propeller blades, which is caused by the "rolling shutter" effect. I rotated the iPhone 90° for each shot to see how the rolling shutter effect varied according to camera orientation.

You might be surprised to learn that unlike most other cameras (DSLR's, etc.), the iPhone doesn't have a physical shutter. With no mechanical shutter, the iPhone has to use another method to create an exposure time for light to reach the sensor. The way it does this is called a rolling shutter, which refers to the way the image spills off the sensor electronically. You can find some neat examples of image distortions that the rolling shutter effect can cause with fast movement (meaning either the subject or the camera is moving faster than the sensor transmits the image information).

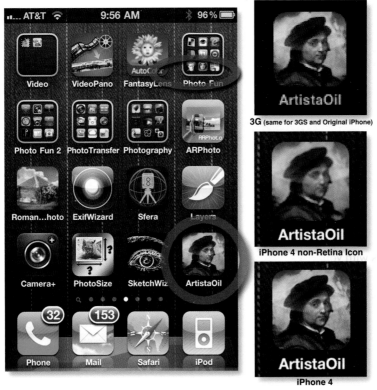

1.3 *Screen resolution and icon display on the iPhone 4, which introduced Apple's Retina display.*

SCREEN RESOLUTION

The table on page 136 shows that the iPhone's LCD screen resolution remained constant for the first three versions (320 x 480 at 163 pixels per inch (ppi)). Apple upped the ante significantly with the iPhone 4, adding four times the number of pixels in the same 3.5" diagonal display space. This gives images stunning clarity on the screen, as well as making text, icons, and everything else more highly defined (also reducing eye strain associated with most mobile tasks). Apple calls this LCD resolution the Retina display, claiming the screen has more resolution than our eyes. (The iPhone 4S has the same physical dimensions and pixel density.)

Photographs instantly look better on the iPhone 4 and 4S, but for app icons to show that extra detail, the developers must design them to be Retina display ready. **1.3** shows a comparison of how an app icon (in this example, Photo Artista Oil) is rendered on an iPhone 3G (which is how it looks on all pre-iPhone 4 screens), the icon in non-Retina display form on an iPhone 4, and how the Retina display icon appears on the iPhone 4. The resolution differences are clear.

STORING PHOTOS

You click the shutter, and then what? Your image is saved somewhere on your iPhone, right? This is where Apple's file system — or lack thereof — starts to feel a smidge too rudimentary. All the photos you shoot with the iPhone camera go into the Camera Roll. There isn't any way to save them anywhere else, unless you resort to a third-party application (or "app"). A few image editing apps let you save your images to Documents, but let's look at how to create Albums within the Camera Roll.

THE CAMERA ROLL

The Camera Roll and all the other Albums reside in the Photos section of your iPhone. If you're just beginning to make photographs with your iPhone, it's a simple process. **1.4** shows one user's Home screen – it is simple and direct, and all of the images are in one austere album. Tapping the Photos button brings up the Albums screen. This is the only place to store iPhone images until you create your own additional Albums in iTunes (explained next).

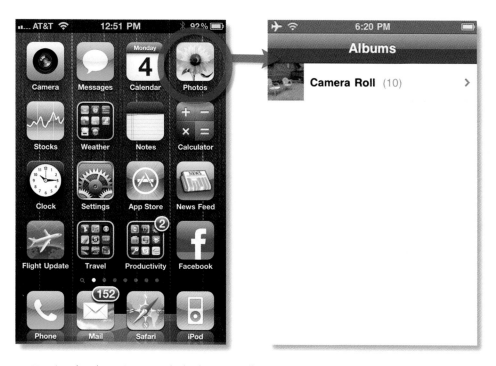

1.4 *Tapping the Photos icon reveals the Camera Roll*

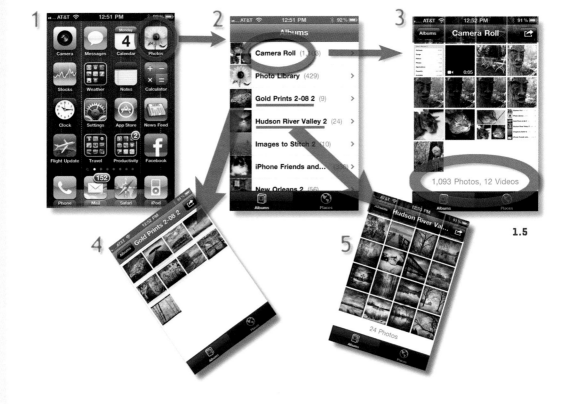

1.5

OTHER ALBUMS

When I tap the Photos icon (screen 1 in **1.5**), the Albums screen opens (2). Yes, the familiar Camera Roll sits at the top of the Album screen, and when I next tap that Camera Roll it opens into the Camera Roll screen (3), where I can gleefully scroll through all 1,093 images contained therein. (Don't even begin to venture as to how many finger flicks it takes to scroll through all those thumbnails.)

Back up to screen 2 for a minute. The other albums listed down the page are additional albums I created in iTunes. These albums are Apple's attempt at an organizational scheme for our photos. As you can see in screen 2, I have about five additional albums listed. Screens 4 and 5 show the two albums, "Gold Prints" and "Hudson River Valley," that are among the five albums I have created with iTunes on my laptop.

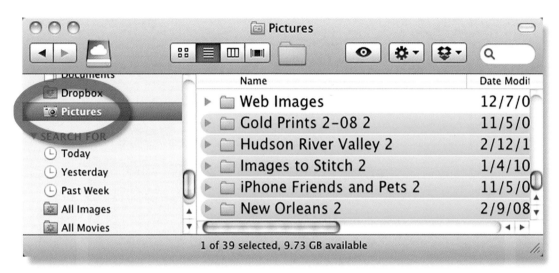

1.6

CREATE ALBUMS IN iTUNES

Unless you are running iOS5 or later (more about this on page 21), you can't create these albums on the iPhone itself—a strange fact given Apple's normal conduct of providing easy, intuitive ways to accomplish tasks. That leads us to iTunes, which is the Grand Central Station for creating albums and syncing and storing images. Let's look at how to create albums via iTunes on either a Mac or PC.

The exact steps are outlined below, but here is the basic approach: Create image folders on your computer (the Pictures folder on Mac and the My Pictures on a PC are the default locations), and then sync your iPhone via iTunes. These folders automatically become Albums on your iPhone under the Photos icon when you sync your iPhone. In the example above, I've created folders for images on my laptop (**1.6**). The green color that I've assigned to these folders has nothing to do with the mechanics of syncing; it's just my way of keeping track of which folders I want to appear as albums on my iPhone.

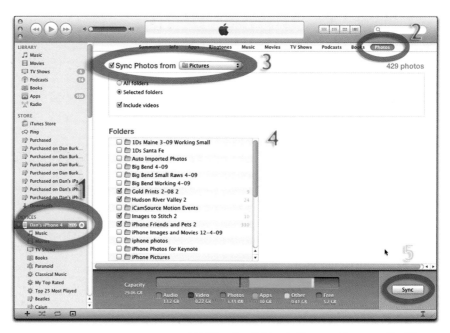

1.7 *Choosing Folders to Sync as Albums on the iPhone*

Now that you have created a folder (or folders) on your computer for images, let's go step by step through the iTunes album creation process in **1.7**.

Using your iPhone's sync/charge cable, connect your iPhone to your computer. Open iTunes on your computer (although it should launch automatically when you connect your iPhone.) iOS5 users are blessed with wireless syncing.

When the iTunes application window appears on your computer (**1.7**), click on your iPhone in the Devices section in the left sidebar navigation (1). Across the top of the iTunes window is a list of tabs that allows access to items you can inspect, set, and sync between your computer and your iPhone. Select the Photos tab on the far right of the list (2). Check the box beside "Sync Photos from," and then choose your Pictures folder (My Pictures is the default location on a PC), from the dropdown menu (3).

There are several options below that "Sync Photos from" option. In **1.7**, I've chosen the "Selected folders" option because I don't want all the folders in my Pictures folder to become albums on my iPhone. When Selected Folders is chosen, iTunes presents a list of all the subfolders nested within the Pictures folder.
Select the folders you want to appear as albums on your iPhone (4).
Click "Sync" (5) to finish.

When the syncing process is complete (you get a message to that effect at the top of the iTunes window), you can disconnect your iPhone and browse the new albums you have created.

CREATE ALBUMS IN iOS5

The iOS5 mobile operating system makes it so we are no longer lassoed to iTunes for simple tasks like creating new Albums – we can create these additional albums right on our phones. **1.8** walks through the steps.

In your Photo Albums, click the Edit button (1). Remember, if you haven't created any additional albums via iTunes or on your iPhone, you'll only see the Camera Roll here. Tap the Add Button (circled in red) to create a new album (2). Notice the red "minus" button next to my Eaves's Ranch Album? This is the only album that I created on the iPhone with iOS5, so it's only the only one I can delete on the iPhone. Albums created in iTunes must be turned off (or deleted) in iTunes. You can name your new Album anything you'd like (3). "Cat Pictures" seems like a good title (you'll see why shortly) so I'll click Save (4).

You'll see a message at the top of the screen suggesting that you add photos to your new album (5). Navigate to any of your existing albums to select images (6). Here I've selected six cat photos from the Camera Roll. Tapping Done completes the operation. Here are the six photos copied to the new Cat Pictures album (7). If you click Done before adding any images, you'll get a screen like this when you open the empty album (8).

Here's one final note about the albums you create on your iPhone. If you delete any of these albums, you do not delete the images in the Camera Roll (or other albums) from which you added the images. In other words, have no fears about deleting these created-on-iPhone albums because they are copied to your new album, not moved to the new location.

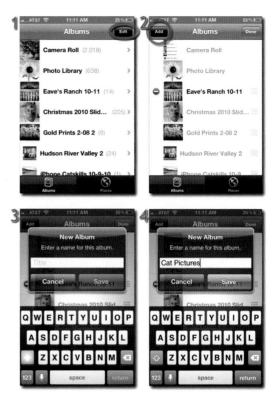

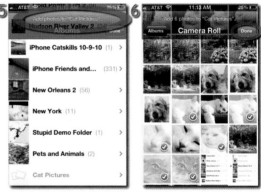

1.8

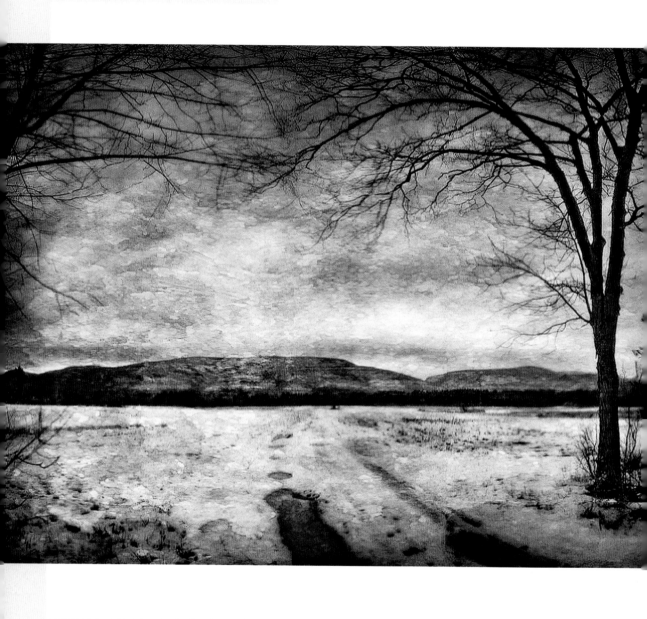

WHAT IS THE PHOTO LIBRARY?

After you create and sync your albums to your iPhone, you might be surprised to find another album appear in the list. The mysterious "Photo Library" is a consolidated album of the images from all the other albums that simply gives you another way to view (in slideshow form for instance) all your images.

EVERY "SAVE" IS A "SAVE AS"

As you can imagine (or perhaps have already experienced), your Camera Roll gets pretty crowded after a while. It gets worse unfortunately; every time you save an edited image on the iPhone, those edited images go into the Camera Roll, too. Suppose you're editing a prize image and you save it 10 times during the editing session. Do the math: you now have ten new versions of that image saved in your Camera Roll. The good news is that, because every "save" is really a "save as," you can't bugger-up an original image — it will still be there in your Camera Roll. That bit of news should give you some peace of mind as you edit your images.

Focal Length: You might notice that the Focal Length figure in the table on page 138 has remained constant. Technically speaking, these specs are accurate, but because the iPhone 4 has a bigger sensor, physics dictates the effective angle of view must increase accordingly. It's much like taking your 50mm DSLR lens and mounting it on a medium format camera. Suddenly that normal lens is a wide-angle optic. It's the same with the iPhone 4: instead of the previous equivalent of 37mm (on a full size sensor DSLR) the iPhone 4 has a wider-angle lens, at about 28mm. If you like wide-angle lenses, this is a good thing.

Take another look at the iPhone 4 image in 1.1 back on page 13. Notice that there is more surrounding subject matter included in the shot, compared to the 3G and 3GS images. This is due to the iPhone 4's wider lens. The iPhone 4S has a longer focal length lens (4.28mm) but the larger sensor keeps the angle of view the same as the iPhone 4.

Let's start our exploration with the camera apps. These are the apps that allow you to use the iPhone's built-in camera in a variety of ways to capture an image. The iPhone's built-in camera app works well, but we can do a lot more by widening our arsenal of camera apps.

Chapter ② Camera Apps

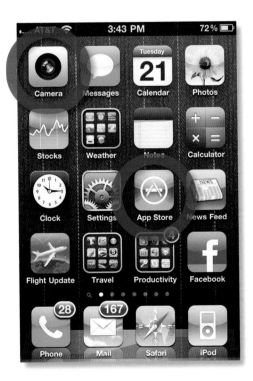

Dan's iPhone Home Screen, Highlighting the Camera App and the App Store

Now we start to get detailed about the apps we can use to capture images with the iPhone. There are just too many apps for any author, reviewer, or individual iPhone user to evaluate, so regardless of anyone's recommendations, you should test the app waters periodically to see what new or improved apps have come onto the iPhone imaging stage. There are always new apps being developed for photographers, so you're going to want to do some bird-dogging to stay on top of the app game. The apps we discuss in this chapter are camera apps that provide enhanced control for shooting photos on the iPhone.

FINDING APPS

There are hundreds of thousands of apps (and counting) available for the iPhone. Photo-related apps account for a small percentage of that total figure, but that is still a boatload of stuff to research. Here's how you can make your app research more efficient.

THE APP STORE

You already have a great place to browse for apps: The Apple App Store. You can access this from your iPhone, or from your computer through iTunes software.

iTunes Search: If you use the iTunes window to find apps on your computer, remember to sync your phone to transfer the apps. You can view apps in different ways when searching for them through iTunes. Figure **2.2** shows the photography apps sorted by category. You can access the App Store through iTunes on your computer by clicking on the iTunes Store in the left column. Then, click on the App Store tab at the top of the screen.

2.1

iPhone Search: Finding photography apps is easiest on the iPhone itself. Launch the App Store from your iPhone by touching the App Store icon. In the image on the previous page, notice that I keep the App Store right on my Home Screen where it's easy to find, right along with the camera app itself. Figure **2.1** shows the iPhone App Store. Click on the Categories button at the bottom of the screen to get a scrollable list of categories.

SEARCH BY RELEASE DATE

Once you select a category, you can sort by Top Paid, Top Free, and Release Date. Release Date is the sort method that could quickly become your best friend. **2.3** shows the iTunes Store and **2.4** shows the iPhone's

2.2

2.3

2.4

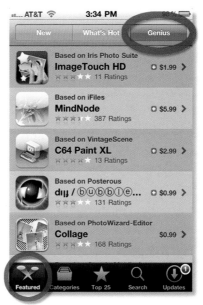

App Store setup to sort by release date. After choosing a category in iTunes, scroll down until you see All Photography iPhone Apps and choose Release Date from the pull-down menu.

USING GENIUS

Apple's Genius feature allows the App Store to recommend other apps that might fit your tastes. Of course, you have to turn on the Genius feature before it can start observing your app habits, so it's at your invitation. I like the Genius feature and have discovered a number of nifty apps that I might have otherwise missed. To activate the Genius feature, tap the Featured button (circled in the lower left of **2.5**), and then select the Genius tab in the upper right.

REVIEW SITES AND APPS

There are web sites and even other apps that evaluate and rate iPhone apps. AppVee (www. AppVee.com) is a fine example of both a website (**2.6**) and an app to help you whittle down your list. Their website works well and a free app also helps you to browse and review apps. Complete with star ratings and thoughtful review videos, AppVee can help you separate the grain from chaff.

2.5

2.6

THE BUILT-IN CAMERA APP

Apple's Camera app is a perfectly capable choice for capturing your iPhone images. The Camera app's interface and operation will vary depending on the iPhone model you're using. **2.7** shows the iPhone 4's camera app in operation on an iPhone 4, displaying a list of on-screen features sported by the various iPhone models. It's important that you know what features your iPhone has so you can both have fun and use them in the most creative ways possible. Here's a breakdown of the various on-screen items:

1. Flash: (iPhone 4 and later) Three positions: Auto, On, and Off ("Off" is the default when shooting in HDR mode)

2. HDR Mode: (iPhone 4 and later): Enables HDR shooting

3. Rear-Facing/Front-Facing Camera: (iPhone 4 and later) Toggles between the two cameras; either still or video mode

4. Still/Video Mode Switch: (iPhone 3GS and later) Choose between shooting photos or video

5. Shutter Button: You guessed it; press here to take a picture

6. Photo Review: Takes you to the Camera Roll to review photos; latest photo is shown in the tiny icon window

7. Digital Zoom: (iPhone 3G and later) Use the slider to zoom in or out (still images only ; with iOS5 you can zoom with a reverse pinch)

Touch to Focus: (iPhone 3GS and later) The focusing feature acts just like it sounds; simply touch where you want the camera to focus

Note: When you use the touch-to-focus feature, the camera also biases exposure for that same focus area. For example, if you touch a light-colored subject, the photo may result in overall under-exposure for the scene. We'll look at how to overcome this problem with another app on page 74.

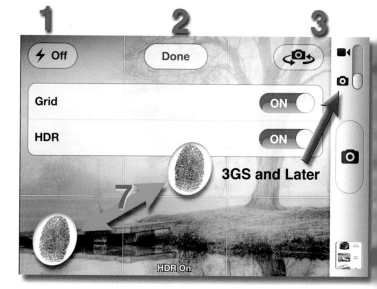

2.7

Why Use It: It's hard to quibble with Apple's built-in camera app. In fact, now that Apple has included HDR as a feature, I find that I'm using the stock camera app more than ever. But—and you just know there's a tease coming here—as proficient as this camera app is, there are good reasons to consider adding a few additional camera apps to your iPhone's collection.

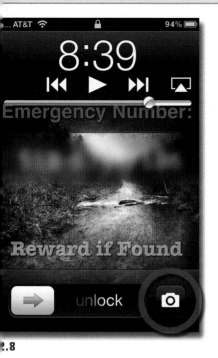

2.8

Immediate Access to the Camera from Lock Screen: A common complaint in pre-iOS5 days was the amount of time it took to actually take a photo from an iPhone that was in sleep mode. That's all fixed now: a double-tap on the home button presents a different unlock screen where you can tap the camera icon (circled in **2.8**) and start photographing almost immediately. This means someone could pick up your iPhone and – even though they don't know your unlock code – could start snapping photos. They could also delete photos from your camera roll but, thankfully, only those taken during this unlocked session.

Note: With iOS 5 and later, if you tap and hold a spot on the LCD, you lock focus and exposure at that location until you tap again somewhere else. In pre-iOS versions, your focus/meter point would automatically relocate if you recomposed. Another benefit of iOS5 is Grid Lines to help with composition. In the icing on the cake category, iOS5 users can use their iPhone's volume-up button as a shutter release!

MORE CAMERA APPS

If you hanker after advanced features like bubble levels to help keep your horizons straight, self-timers, remote shutter capabilities, and grid lines—there's an app for that! Let's look at a few of my favorite camera apps.

Note: A number of iPhone image editing apps also provide camera functionality. Though this might seem handy, since you don't have to quit the editing app to make a new capture, it's rare that these shooting utilities are as good as the standalone camera apps.

General	**About**	
Dan's iPhone 4		
Network		AT&T
Songs		3,176
Videos		13
Photos		1,510
Applications		231
Capacity		29.1 GB
Available		4.2 GB
Version		4.1 (8B117)

Dan has far too many apps on his iPhone!

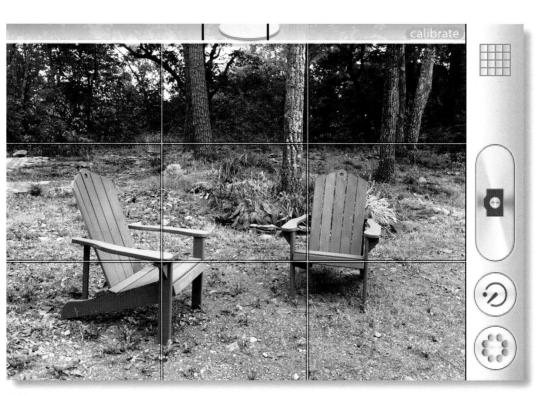

2.10

GORILLACAM

The excellent Gorillacam (www.joby.com/gorillacam) adds goodies like bubble levels (for both landscape and portrait orientation), self-timer, grid lines, anti-shake, and digital zoom. You won't get the built-in camera app's HDR feature, but that limitation currently applies to all the shooting apps that aren't dedicated HDR apps. **2.10** shows Gorillacam's settings. **2.11** captures Gorillacam in action, with the bubble level and grid features turned on. Notice the easy access to the self-timer mode (the clock-like button). Gorillacam can't be beat for the price (free) but let's look at what a few dollars can get us for a shooting app.

2.11

PROCAMERA

There's just no way around adding at least one paid camera app to your collection. One best-of-breed camera app is ProCamera (www.procamera-app.com). This app combines a straightforward interface with a rich feature set. (Now doesn't that sound like an endorsement?) The very best thing about ProCamera has to be the ability to separate the focus point from the metering point. At it's most fundamental, this means you can focus where you want in the scene but bias your exposure to another area in the image. This can be amazingly handy when shooting for post-capture HDR. And this feature works for the 3GS, iPhone 4, and 4S.

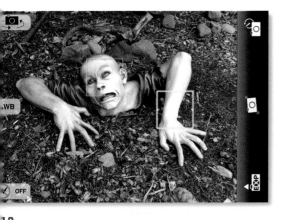

12

In **2.12**, notice that I placed the focus point (the blue square) over the zombie's face, but I placed the exposure meter (yellow square) on the arm and surrounding dirt to get the exposure just right (this is particularly important when trying to accurately capture zombie flesh tones).

As you can see in **2.13**, there are a lot of options in ProCamera. Here's a partial list that corresponds to the numbers in the figure:

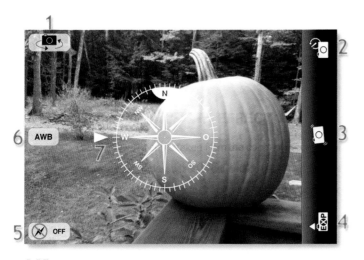

2.13

1 Rear-facing/front-facing camera toggle (iPhone 4 and later only)

2 Self-timer that's cancelable and adjustable from .5 seconds to 20 seconds

3 Anti-shake shutter button

4 Options and settings (grids, video camera, editing controls, digital zoom, etc.)

5 Flash on/off/auto

6 Auto/Lock White Balance (see page 32 for more on this great feature)

7 Compass

You should be getting the point that ProCamera is jam-packed with useful and fun features. For those who want a simpler set of options with fewer icons on the screen, turn off Expert mode in ProCamera's settings.

Before moving on, there are two points of interest. First is that you can touch anywhere on the screen to take a picture. Second, and more importantly for photographers, is ProCamera's White Balance Lock (**2.13**). This feature alone makes ProCamera an essential app on my iPhone and should do the same for you.

White Balance Lock: White balance controls the camera's color response—more specifically, the camera's response to colored light sources. The idea is to make white objects appear white, neutral objects neutral in color, etc. A "correct" white balance setting results in pleasing colors no matter what the light source, be it incandescent lamps, sunlight or fluorescent lights. Happily, our iPhones perform automatic white balance and do a pretty good job of it – usually. Some lighting environments fool the iPhone's sensor; when this happens you get a color cast in your image.

Note: I actually used a morsel of white matte board to lock white balance in figure 2.13 but any gray card or white card will do. White coffee filters work great because they are cheap, easy to carry and easy to find.

Auto White Balance

2.13 Using White Balance Lock with ProCamera

ProCamera Specs

Feature	iphone 3G	iphone 3GS	iphone 4	iphone 4S
Anti-Shake Image Stabilization	•	•	•	•
Adjustable Self-Timer	•	•	•	•
6x HQ-Zoom	•	•	•	•
Virtual Horizon	•	•	•	•
Alignment Guides	•	•	•	•
Manual Focus & Exposure (combined)		•	•	•
Separate Focus & Exposure (Expert Mode)		•	•	•
Auto Exposure	•	•	•	•
Manual Exposure (Expert Mode)		•	•	•
White-Balance Lock (Expert Mode)		•	•	•
Full-HD Video Recording (1080p 30 fps)				•
HD Video Recording (720p, 30fps)			•	•
HQ Video Recording (480p, 30fps)		•	•	•
EXIF data storage	•	•	•	•
EXIF data view	•	•	•	•
Geotagging	•	•	•	•
Extended Geotagging (+ compass direction)		•	•	•
Pro-Compass		•	•	•
ProLab Studio	•	•	•	•
ProCut Studio	•	•	•	•
ProFx Studio		•	•	•
In-App Manual	•	•	•	•
Tips & Tricks	•	•	•	•
RapidFire	•	•	•	•
QuickFlick	•	•	•	•
Social Sharing	•	•	•	•
Steady Light			•	•
Volume Trigger	•	•	•	•

Because ProCamera includes so many features, not all of them work on every iPhone model. This shows the developer's list of features as they apply to the different iPhone models.

2.13 illustrates a typical scene that can fool the iPhone's auto white balance. This shot shows a mix of sunlit background areas with an open shade foreground. I took one photo with ProCamera set to Auto White Balance (the default and the way the built-in Camera app behaves also) and then I used ProCamera's White Balance Lock to measure a white card for a better color rendition in the other photo. The auto white balance shot is much too blue; the camera was fooled by the brightly lit background highlights, which were sunlit. When I used a white card to Lock ProCamera's White Balance, the blue cast vanished.

> **Note:** Like ProCamera, ClearCam also has a means to focus on one area of the scene and meter off another.

CLEARCAM

Just as there are computer programs like Photo Zoom Pro 3, Blow Up 2, and Perfect Resize to increase the pixel count in our computer-bound digital images, there are 3rd party apps that attempt to do the same thing with images on the iPhone. ClearCam's biggest claim to fame is that it produces iPhone images with twice the resolution of the iPhone's built-in camera app.

Most 3rd party camera apps (including GorillaCam) that promise sharper photos use a form of anti-shake technology (As this book goes to press, the Enhance Mode of ClearCam does not work with the iPhone 4S.). Notice I didn't call it image stabilization or vibration reduction; those hardware-based technologies, found in our DSLR lenses (and some camera bodies) are an active means to a sharper image. These methods are not to be found in any of the first five iPhones up to the iPhone 4S. Instead, when you touch the shutter button, the app uses the iPhone's motion sensors to detect when the iPhone is moving as little as possible before firing the shutter. This method works surprisingly well as a way to reduce photos ruined by camera movement. (Pro-Camera even has a range of sensitivity you can set for its anti-shake feature.) ClearCam takes a different approach. One of ClearCam's sleeper features is what they call Quick Mode. In Quick Mode, the camera takes four pictures (or more, depending on your iPhone's camera resolution) in rapid succession, and then saves just the sharpest one to your camera roll. ClearCam examines the four frames and then saves the one image from the group with the least amount of blur. This method takes into account both camera shake and subject movement, so it can be a life saver in everything from group portrait shots to photographing from a moving vehicle (as a passenger, of course).

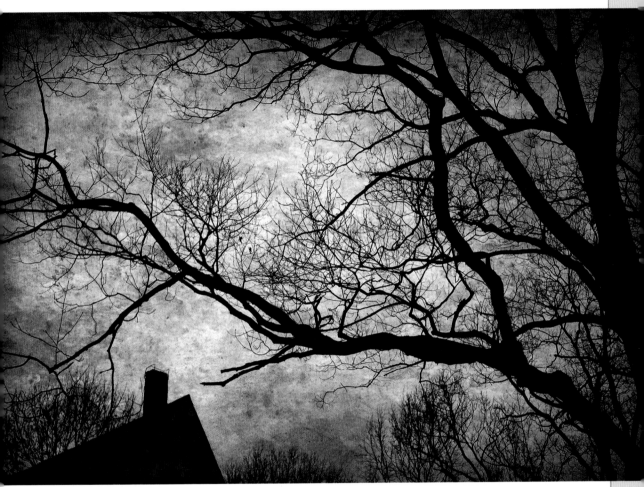

Tree and House, Palenville

Note: Remember, there is no substitute for real resolution made during the exposure. All up-sampling methods are something of a compromise in terms of quality and detail. Having said that, ClearCam's results are pretty amazing for iPhones up to the iPhone 4.

After we hit the shutter button on our iPhones, the post-process-ing decisions begin. Cropping, sizing, and sharpening decisions are first on our to-do list after an image is safely stored in the Camera Roll. We can use the apps discussed here for the simple, but oh-so-important, first steps.

Chapter ③ Basic Editing Apps

● EXPOSURE & COLOR

First let's explore some apps that are profi-cient with editing the exposure of your image, much like the Curves tool.

Note: In the Photoshop classes I teach, I for-bid the use of Levels as an exposure correction tool because Curves can do everything Levels does, plus a lot more. Editing on our iPhones with much less screen real estate at our disposal is a different beast. Levels provide an easy and direct first step in our contrast control regimen.

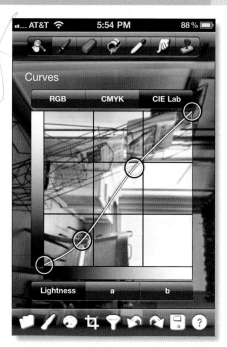

3.1-*PhotoForge's Terrific Curves (here in Lab mode)*

PhotoForge: PhotoForge (www.ghostbirdsoft.com) was one of the first iPhone apps to give us Photoshop-like editing control. One of the biggest features that PhotoForge brought to the table was Curves. I tell digital photography students ad nauseam that if they master Curves and Masks, then they have much of Photoshop's "real" photographic control conquered. PhotoForge has Curves, but with a twist: You can bend curves in RGB mode, in CMYK mode, and even in LAB mode (see the sidebar for more info on these color modes). **3.1** shows an image with PhotoForge's Curves in action. The CIE LAB tab of the Curves dialog box is highlighted because working in LAB we avoid color shifts that can occur when we use curves in RGB or CMYK modes.

Though it might be hard to make out the actual image with the Curves dialog box overlaying it, you should notice that the horizontal image of a diner interior is presented vertically. All images, regardless of whether they are shot in portrait or landscape orientation, are opened in portrait mode in PhotoForge. Let's hope the app developers give us an option to change this in a future update.

PhotoForge2 is the newer version of GhostBird Software's editing and stylizing app. It doesn't replace the original; in fact, I still use PhotoForge for simple texture-adding jobs. PhotoForge2 raises the bar with its advanced masking features, so you should spend some time learning this deep – and not so intuitive – app.

PhotoWizard-Editor: PhotoWizard (www.beltola.com) lacks the full-throttle Curves options of PhotoForge, but has a more modern and user-friendly interface. Of its features, I particularly like the Levels tool that updates the histogram in real time as you move the sliders. (Photo Wizard's masking talents are used in the Workflow chapter on page 110.) If you ever use the Magic Wand tool, you'll probably love PhotoWizard. With the easy swipe-left-to-undo feature, and the live update of their Levels settings (**3.2**), Photo Wizard is one of the first apps I go to for Levels and Sharpening.

3.2

Color Modes

RGB: Photographers are concerned with three colors: red, green, and blue — or RGB. The iPhone camera sensors—like most sensors in digital cameras today—have filter arrays based on these same three colors, so it only makes sense that our editing apps honor that same color mode. In RGB mode, we create all the color and contrast in our images by adjusting the hue (the color), the intensity (saturation), and the brightness of those three primary colors of light. It's a pretty simple system overall.

CMYK: The world of printing presses, on the other hand, deals with cyan, magenta, yellow, and black because those are the four inks that standard printing presses

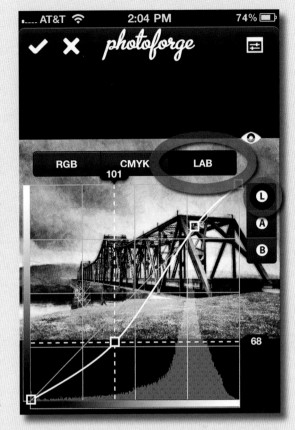

use. This is called CMYK mode (the "K" refers to the key color, black, to avoid possible confusion with blue). If you aren't going to press with your image, there aren't a lot of reasons to concern yourself with CMYK mode, even though apps like PhotoForge do provide it as a color mode option. In all color modes, we refer to the three or four colors as the "channels" into which our image is divided.

LAB: LAB mode is the weirdo of the color mode arena. Instead of breaking up our colors into either three or four channels (as in RBG or CMYK modes) LAB separates the luminosity (a fancy word for brightness) from the color in our images. LAB is shorthand for luminosity (the L channel), and two channels of color referred to as "A" and "B." The "A" channel deals with colors on the magenta to green scale, and the "B" channel covers the yellow to blue color range.

It's beyond this book to serve as a LAB mode primer, but a simple explanation is certainly in order. Sometimes when we adjust image contrast via curves or levels, we get an undesirable color shift. This is a common problem with RGB images so you might notice this bad behavior in your Photoshop images also. If we perform our Curves or Levels adjustments in Lab mode using just the L channel, we are only adjusting the luminosity in the image, avoiding potential color shifts.

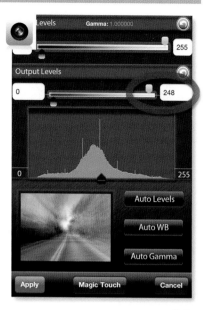

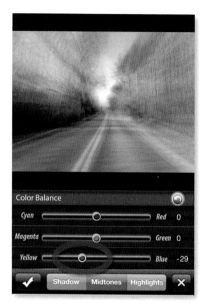

3.3

3.4

Iris Photo Suite: When you want to notch up your Levels power a bit, Iris Photo Suite (IPS) (www.ventessa.com) is just the ticket. **3.3** shows how the Levels in IPS gives us not just Input control but also Output. This comes in handy if you want to limit the brightest area in your image to a very light gray (248 for example) instead of having paper-base white highlights.

Another wonderful feature is IPS's Color Balance. This lets you shift tones in shadows, midtones and highlights. In **3.4** I've tweaked the midtones toward yellow (in the second screenshot) to eliminate the blue cast in the blacktop road.

Photogene: Though I find I'm using it less often than the apps mentioned above, Photogene will always have a place in my iPhone imaging heart. It was one of the first editing apps I used (thanks to the recommendation of digital expert and friend, Jack Davis) and it opened doors. In **3.5** I'm cropping an image in Photogene. Notice that, as I drag the cropping rectangle with the cyan corner dot, Photogene gives a real-time readout of the cropped pixel dimensions. That's both courteous and very useful.

3.5

RESOLUTION

Before purchasing any photo apps, research the app's resolution capability. Some apps honor the iPhone's native resolution, but some—instead of saving all of your original pixels to your camera roll—will save a smaller version. If you're content with that decision then no harm done. But many of us don't want our precious pixels discarded with disdain. There are a couple of ways you can learn about the app's resolution protocol.

What if neither the app description nor user reviews gives you a clue about the final image resolution of a shooting or enhancement app? Sometimes you just have to gamble by purchasing the app and checking for yourself see how your camera resolution is respected or trashed. Wouldn't it be nice if we could find a way to check image size quickly right on our iPhones? Well, there is.

Metadata Apps: Digging Deeper

PhotoSize is quick and straightforward about revealing the pixel dimensions, and does one more thing that scores major points: When you click the Choose Photo button, PhotoSize takes you to the last-shot image in your camera roll. That might not sound like a big deal, but if you have over a thousand images in the camera roll at any one time, it's a time-saver to not have to scroll through all those images to get to a recent one.

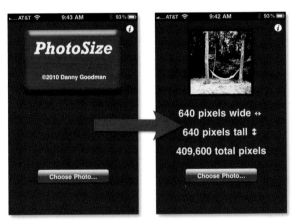

3.6

 PhotoSize: Danny Goodman's excellent – and free – PhotoSize (www.dannyg.com/iapps), is a handy app I keep on my iPhone just for such resolution checks. This is a lot faster than taking the image into Photoshop just to check image dimensions and even faster than launching an app like Perfect Photo, which does politely shows pixel dimensions as soon as you load an image. (More about Perfect Photo in the Cropping section below.)

PhotosInfo: Sometimes, either from legitimate need or sheer curiosity, you want access to all the metadata—like shutter speed, ISO, date and time, etc.—of an image. Here again you have a wealth of options, but my favorite is PhotosInfo (www.osm4iphone.com/PhotosInfo). Though not free like some other metadata apps, PhotosInfo has a graphic interface that looks much like the screen on a DSLR camera.

CROPPING

When it comes to apps, we have two flavors: free and paid. If your iPhone is up to date with iOS5 or later, you have built-in cropping available via the Edit menu in your Camera Roll. If you want more control over your image cropping, let's take a look at some good options.

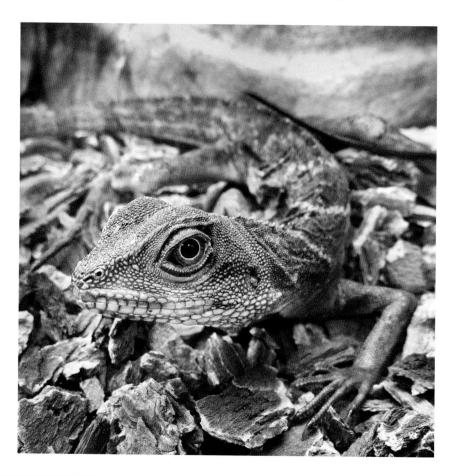

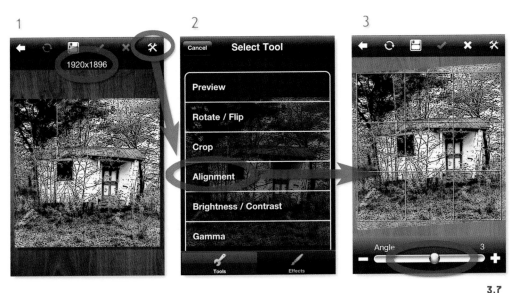

3.7

CROPPING PRECISION

Even though you compose as carefully as you can on the iPhone LCD, you will encounter images that need a nip or tuck to make the composition just right. For such jobs, you can spend a few bucks on apps that offer more advanced cropping options.

Perfect Photo: When a bit of rotation is in order, a number of apps do the trick. One that works for such cropping and other editing tasks is Perfect Photo (www.macphun.com). **3.7** shows the sequence of screens and buttons I used to crop this photo of an abandoned cabin in the Hudson River Valley.

Perfect Photo shows the pixel dimensions when you first load your image. In this case, the image is 1920 x 1896 pixels. The Tools menu (circled in blue) is where you find Perfect Photo's power. The Tools menu presents a list of app functions; the Alignment function tilts the image back and forth by moving the slider. The grid lines provide a reference for horizons or buildings.

Note: See page 60 for additional cropping tips using Mirage Photo Studio. Mirage can perform warps and perspective control on your images in addition to basic cropping actions.

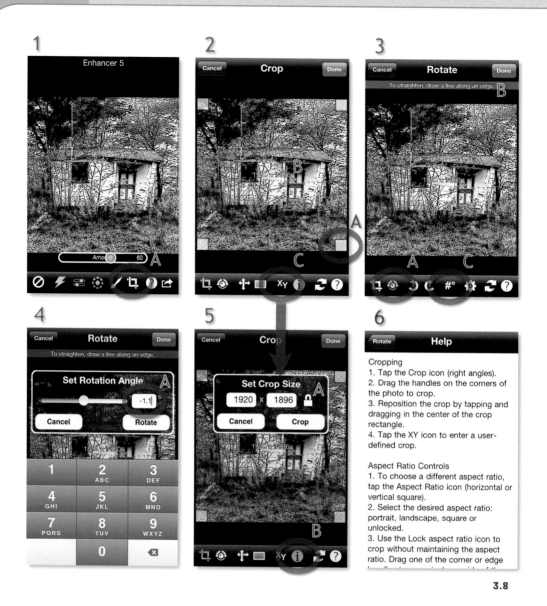

3.8

Photo fx: Perfect Photo showed its stuff, but if you need to finesse your image crop, look to a company that knows about filters. Photo fx (www.tiffen.com) is an app that gives you almost total control over cropping. It is also one of the best filter effects apps we have in our iPhone arsenal. (We look at the filtering feature of this app when we get to the workflow section on page 107 of this book.) Let's examine how Tiffen has taken pains to make our cropping painless **3.8**.

When I want to make a crop, I tap the crop icon (1A) to bring up the cropping handles (2A). As you drag the cropping handles, the cropped image size appears in the center of the image (2B). Tapping the XY button in 2C takes you to screen 5, where you can numerically designate the crop size in pixels (5A). The lock button lets you decouple the aspect ratio so you can crop to any dimension.

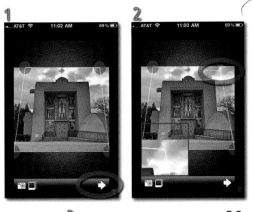

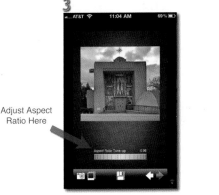

3.9

Adjust Aspect
Ratio Here

3A opens the door to visual straightening. 3B shows the text directing you to drag a line along a horizon (or vertical building edge, for instance) to straighten crooked images. This behavior is just like Photoshop's Lens Correction Straighten Tool. The numeric button (3C) takes you to screen 4.

You can either drag the Set Rotation Angle slider (4A), or you can use the keyboard to designate the amount of image rotation you want to apply.

The last feature I want to cover is the information button (5B) that brings up the very comprehensive help screen (6), which is context sensitive, so it shows information related to the area of Photo fx in which you're working.

Note: Remember, whenever we apply transforming operations on our images (perspective crops and warping, for examples), the image undergoes interpolation. That means good pixels are eliminated and new, artificial pixels are created. This means there is a chance that image artifacts, noise, and other flaws can start to appear. Use perspective crops and warps sparingly. (If you plan to introduce texture into your image, however, these flaws may largely disappear in your final image.)

FrontView: When you need to perform a perspective crop (a crop that fixes keystoning or tilt in your image), there are only a couple of apps that can oblige you. FrontView (www.mediachance.com) is one such great app. When you first open your image in FrontView (3.9), four red cropping handles are situated on your image (1). Moving the selectors into position takes some practice on the iPhone screen, but it's an easy art to master. When you move one of the corner selectors (2), FrontView creates an enlarged inset window so you can move the crop handle with precision. The cherry on the top of this cropping sundae is FrontView's Aspect Ratio Tune-up (3), where you can tweak the image's height/width that often is distorted when performing perspective crops. This app supports the full resolution of your camera, though expect a few pixels less since it is a crop you're performing.

When Dragging a Crop Corner Is a Pain: FilterStorm

If you haven't discovered it already, I promise you will. You're trying to crop out an edge or top/bottom of an image and the app seems to have a mind of its own. Here's what happens. You tap and drag one of the cropping handles and find it's almost impossible to move the cropping handle in one axis without altering the other. Yes, what you've discovered is the hassle of corner cropping handles that make it a chore to move just one side of the crop accurately. There is a solution, and it's called FilterStorm. We'll go into great detail on FilterStorm's many talents in the Workflow chapter on page 107, but for now, let's spend a moment with this app's solution to the corner-crop-handle issue. The beauty of Filter-Storm's approach to cropping is that, instead of using a hard-to-control corner handle, its cropping is governed with four independent crop lines.

We start with the image cropped for perspective in FrontView (above), which is almost done except for too much empty image area at the top. Filter-Storm's two main working menus are Canvas and Filters; first select Canvas and then tap on Crop.

iPhone Artistry

Next, as shown in the figures below, drag the top crop line down to eliminate the unwanted area (1). The pixel dimensions are displayed as you move the crop lines. Should you want to observe or control the aspect ratio, tap the Show Ratio button (2). Here you see the aspect ratio displayed. When the image looks the way you want it, tap Crop in the bottom menu bar.

Be careful here. It's easy to overlook the Quick Save vs. Export Large option in the Save dialog (3). Unless you are only sending your image to Facebook or a similar small file use, choose the Export Large option.

RESIZING

Sometimes you just need to make an image smaller, or you want to transform it, stretching it vertically or horizontally.

iResize: iResize (www.jodymcadams.com) is deceptively simple at first glance. But when it comes to changing sizes and maintaining (or altering) the aspect ratio of your images, iResize is a gem. **3.10** shows how I used iResize to change a rectangular image into a square one. These screenshots show the process of cropping a vertical image into a square. Note the new pixel dimensions (1000 x 1000 pixels) in the third screen.

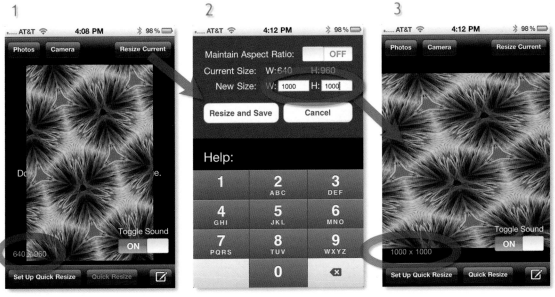

3.10

Barn and Trees in Snow

A big reason many of us choose the iPhone as our phone/camera is the amazing assortment of creative apps available in the App Store. We've discussed apps that can substitute for the built-in camera app, and apps for basic image editing. Now our focus turns to apps that we use to stylize and enhance our iPhone photos.

Chapter 4 Creative Editing Apps

Note: When you install a new app, check the Settings to make sure they are set to give you the desired effect. Be sure to check in both the app's internal settings and the iOS Settings..

● SHOOT & MODIFY APPS

As you seek out apps to stylize your iPhone captures, be aware that there are two ways developers go about giving you this stylistic power. The shoot-to-modify app approach assumes you want to actually turn your iPhone into a different type of camera. When you click the shutter, the image appears in modified form, be it a pinhole effect, instant film, plastic lens, or other neat image-changing effects. The downside to this is that you may not get a straight version of your image for later use. In other words, before using one of these camera apps, make sure your subject is one that you never want to see again as a non-manipulated photograph. (A few of these stylize-as-you-shoot apps, but not all, give you the option to "save original image" into your camera roll.)

Hipstamatic: If you like this unplanned approach to your images, Hipstamatic (www.hipstamaticapp.com) is a popular choice in the App Store. Several different lens effects, processing looks, and borders are included, but you can add to the fun with in-app purchases. In fact, if you buy everything possible, it'll set you back about $7, which is a healthy sum for a photo app. **4.1** shows Hipstamatic's "viewfinder" and a final processed image.

Slit-Scan Camera: The world of slit camera photography is one of building an image, slice by slice, almost like piling a stack of bologna on its side. Capturing slit camera images with a film camera was never an easy or predictable affair. With an iPhone it's easier, though the predictable part still remains a bit elusive.

4.1

You can vary the slices-per-second rate (and other capture attributes), so you'll quickly learn a combination that suits you and your subject matter. The key is to remember that the slit camera apps rely on either subject or camera movement to create the scanning effect.

POST-PROCESSING APPS

The second approach to image enhancement is employing apps that use images from your camera roll (or other albums) and apply a wide range of effects. I favor this type of post-processing app because the original image is safely recorded, so you are free to take the modifications in any direction you like.

There are a plethora of these apps. Some are faster than others, some preserve your resolution better than others, some have a greater variety of effects, and some provide collateral editing features (like cropping or tonal control) in addition to their primary goal of stylizing your image.

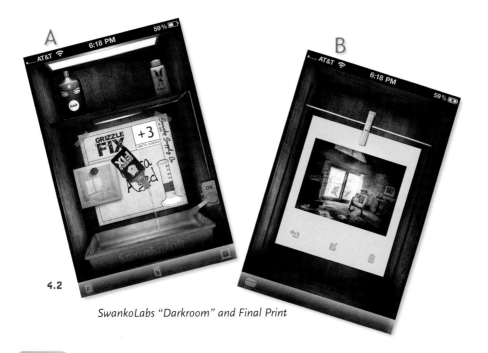

4.2

SwankoLabs "Darkroom" and Final Print

 SwankoLab: The same people who bring us Hipstamatic have a sister app called SwankoLab. This post-process app uses classic darkroom inspiration; to create effects, add different chemicals to the developer tray. One of the best features in SwankoLab: Once you create a "formula" that gives image qualities you like, you can save the "recipe" to apply to future images. The visuals and sounds in SwankoLab are almost better than the effects themselves. Your photo friends will be impressed when you demo this app for them. **4.2** shows how chemistry is added to the developer (A) and the results of the final image (B).

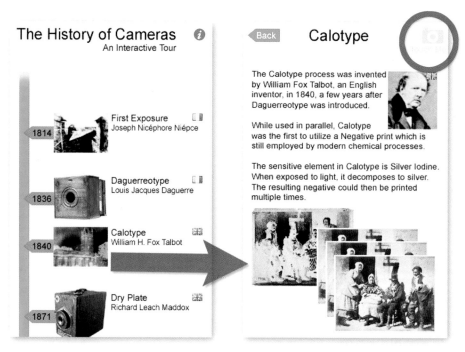

4.3 *The History of Cameras*

The History of Cameras: Occasionally you come across a free app that is simply astounding. Such is the case with The History of Cameras (HOC). Not only does HOC provide a succinct overview of photography's hardware advances since its beginnings in the early 1800's, it also lets you capture photos that (somewhat) simulate the camera/lens combination from that era. **4.3** gives you a taste of HOC. Clicking on a process takes you to a screen with more information on both the inventor and the process itself. Tapping the Touch Me button (circled in **4.3**) lets you take a photo that digitally mimics the selected process. If you love photography, get The History of Cameras!

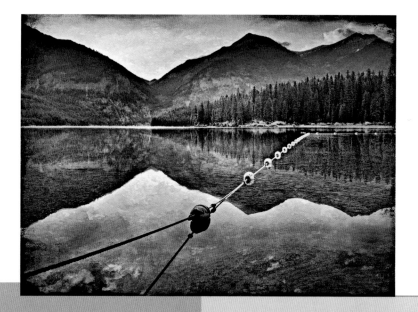

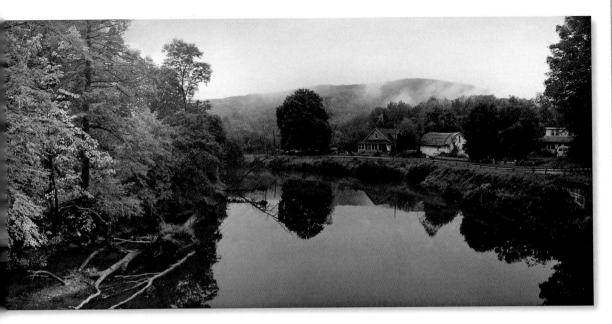

◉ FILTERS AND EFFECTS APPS

Here's a topic that is dear to my heart. It's funny: On the computer, I was never drawn to software filters. With the iPhone, however, it's a different story – filtering images seems almost natural. These apps are very ubiquitous, so let's sift through the mass to find those that deserve attention.

FX Photo Studio: Here's a must-have app. With no fewer than 140 different photo effects (probably more by the time you read this), you will lose hours of your life—in a good way—experimenting in FX Photo Studio (www.fxphotostudioapp.com). In fact, the app developer must have realized that you were getting almost too many effects to keep track of in any kind of organized way. So they created a "favorites" system where you can bookmark the filter effects that you really like and want to use repeatedly. Of course, to find your own favorites, you have to try the filters. **4.4** in the next section shows how I applied FX Photo Studio's Rusted Metal filter to an image that had already had some texture added in PhotoForge. (This is a not-so-subtle hint that sequential filter effects can be a large part of iPhone magic.)

54

PhotoForge's Watercolor Filter:
PhotoForge is known for its advanced exposure control using curves, but also for several of its filter effects. Two of my favorite filters are the Watercolor and Oil painting filters. **4.4** shows how to access the Watercolor filter. Tapping the mysterious funnel graphic in PhotoForge's toolbar (the bottom row) brings up the list of filters. Scroll until you see Watercolor and Oil painting. When first applied, the Watercolor filter is at full strength. Besides darkening the image tremendously, the full amount is usually too heavy. Reducing the filter's strength by about ½ gives the image intrigue without the heavy-handed look.

The Oil painting filter in PhotoForge works much the same as you see in **4.5**. Again, full strength can be a bit much; dialing it down fine-tunes it to a point where we get the warm, Hudson River School of Painting look.

VintageScene: One of the things you'll appreciate about VintageScene (www.jixipix.com) is that, once you discover or create an effect you like, you can save it as a preset that can be applied to future images. Notice in 4.6 the texture is fairly dark and lacking contrast. That's because VintageScene is normally used to apply a texture to a "real" image with detail and a range of tones, and it does a good job when used as intended. Here, I used a photo of a white wall as the image to texturize so it comes out looking pretty flat. Click the Save button (circled in **4.6**) and you see the confirmation message shown in **4.7**.

4.4

4.5 Photo-Forge's Oil painting Filter in Action

4.6

4.7

4.8 *Aspect Ratio Decision in SketchMee*

SketchMee: SketchMee (www.studiomee.com) turns your continuous tone color images into pencil-like illustrations. When you first open your iPhone image in SketchMee, you choose an aspect ratio (the ratio of the width and height of the image) as in **4.8**. Here, I've chosen 4:3 because that's the native aspect ratio of the iPhone. You can rotate your iPhone to make the aspect ratio fit either horizontal images (like this HDR shot of the interior of an old Hudson car) or vertical images. There is a plethora of sketching options in SketchMee: a handy help dialog appears when you scroll to the top of each control (see **4.9**).

4.9 *Handy Tips at the Top of Each Adjustment Option*

4.10 *Pencil (top) and Chalk (bottom) in SketchMee*

4.11 *Color Options in SketchMee*

One of the first decisions to make is whether you want the effect to be like a chalk drawing or a pencil sketch. What's the difference? I think of it like this: a chalk drawing starts with a blackboard and white chalk is applied. The shadows have the least chalk and the highlights have the most. A pencil sketch starts with white paper and black pencil is applied, so the shadows have the most pencil and the highlights have very little. How this difference looks is pretty logical when you think about it. If you want the most "sketchy" detail in the highlights, then chalk is the way to go since it takes more strokes of chalk to create those light areas on the blackboard. If the shadows are where you really want to see the sketchiness, then the pencil is the way to go because lots of pencil is applied to the white paper in order to make them dark. Take a look at **4.10** to see how chalk and pencil compare. All options except the pencil/chalk choice were kept the same. (I normally keep most of the other SketchMee controls pegged to their maximum value; you should experiment to find your own taste of "sketchiness.") Normally, the look and feel of chalk is softer and more inviting. And when you couple this with layering to control the amount of texture, the results can be amazing.

If the monochromatic look from SketchMee leaves you wanting more, experiment with Color Pencil and Color Chalk filters. When you choose either of these coloring techniques, many of the other options change, too. **4.11** shows the same Hudson car interior using the Color Chalk filter.

SAVE SKETCHES AS PHOTOSHOP PDFS

This is exciting – you can open PDFs at any resolution you wish in Photoshop. When you tap Open, your size, resolution, color mode, and bit depth options are listed.

Save Options: When you have created a textured image to your liking, save the image to the camera roll. (1) SketchMee gives you several JPEG sizes from which to choose; here, I chose the 1720 x 1280 resolution. (2) Notice the "PDF" option: with an in-app purchase you can add PDF functionality to SketchMee. This shows the Export dialog box set to email the image as a PDF.

Opening an Exported SketchMee PDF in Photoshop: Photoshop's Open dialog box shows the SketchMee PDF about to be opened. Once you click Open, you're faced with a new set of decisions; the PDF must be rasterized to create a bitmapped image in Photoshop. You can also open SketchMee PDFs in Adobe Illustrator or other vector based applications.

Import PDF Dialog Box in Photoshop: In this case, I opened the PDF as a 22 x 30 inch grayscale image with a resolution of 180 ppi (pixels per inch).

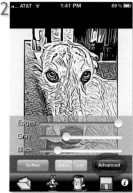

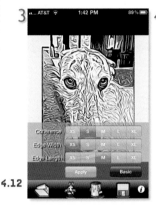

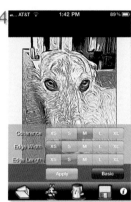

ToonPaint: Our next app for exploration is ToonPaint (www.toon-fx.com/toonpaint). The name is derived from "cartoon," but that doesn't mean you can't use ToonPaint for real photographic endeavors on your iPhone. In **4.12**, a picture of sweet Trudie has been opened in Toon-Paint. With the ToonPaint effect adjusted to look best, it's time to save this stylized version of the image and take it into Layers for some hybrid image tweaking (**4.13**). (We discuss Layers in Chapter 8.)

ToonPaint Options: *(1) The original photo of Trudie. (2) ToonPaint's basic options. (3) In the Advanced option, you can fine-tune the line effects. (4) Taking Coherence up and Edge Length down made finer sketch-like lines.*

4.12

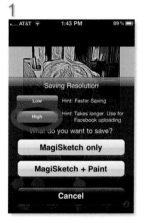

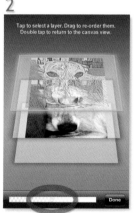

4.13

ToonPaint and Layers:
A sneak peek of using Layers to build images

iPhone Artistry

Photo Copier: Photo Copier (www.digitalfilmtools.com/iphone) is an amazing, artistic app with a misleading name. A better moniker would be "Art Emulator," or even "Photo Plagiarizer." Photo Copier has the amazing ability to visually overlay the color, texture, and detail rendering from other art works onto an iPhone photo. The four categories—movie, painting, photo, and process—give you a wide range of effects. The only flaw with Photo Copier is that, once you stumble upon a combination of Color, Texture, and Vignette (the three root variables that you can adjust for each artist's style) that "works" for your image, there is no way to save it as a preset, as in some other apps. Maybe this omission will be corrected in a future update of Photo Copier, but until then, to paraphrase a former Defense Secretary, we come to iPhone image enhancement with the version of the app we have, not the version we'd like to have. If you want to keep a record of app settings that you like to use in Photo Copier, you have two options: You can write them down, or you can take screenshots of the settings.

> **Note:** You can save an image, or a screenshot, of what shows on your iPhone's touch screen by pressing the Home key and the Power button at the same time. The image is automatically saved to the camera roll.

OTHER CREATIVE APPS

Are you overwhelmed yet? Or, just broke from purchasing these inexpensive apps? Well, let's talk for a moment about a couple more that you really must have.

TiltShift: One of the disadvantages to using a small sensor camera like the iPhone is that our depth of field is very generous. For those times when you'd like to have an out of focus background (to emphasize the foreground subject), TiltShift (www.imimux.com) is the perfect tool. We'll revisit this app in future chapters for sure.

Art Studio: A favorite among layer lovers, Art Studio (www.iphoneclan.com) does have a resolution handicap similar to Layers. But with a load of art-centric features like fade-out brushes and export to PSD (like Layers), Art Studio has earned its loyal following. Be aware that resolution is limited to 1024 x 1024 pixels on the iPhone 4. If you're uncertain, there is a free version you can try before committing your $1.99.

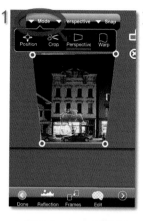

4.14

PaintBook: If vector drawing is one of your passions check out Paint-Book (www.paintbook.ca). With PDF export (for high resolution printing) and amazing text control (font, line spacing) and brushes sizes from 0.1mm to 100mm, this app approaches desktop application power in a vector drawing package.

Mirage-Photo Studio: Mirage (www. mexircus.com) is one of the few apps that offers perspective changes and warping. And with image masking and filtering, it's a lot of app for the money. Here are some of the features offered in Mirage in **4.14**.

Under the Mode menu are ways to perform perspective resizes, warping and other shape shifting maneuvers that are hard to find in other photo apps. In **4.14**, I've chosen Mode>Perspective, and have dragged the perspective handles. Another great feature of Mirage is that as you add images (as layers), you can change their position, alignment, and rotation. Also, just like Photoshop, images snap to a grid as you move them. This applies to text that you can add in Mirage, too. And, as often happens when working in layers, Image Opacity is just a slider-drag away. I'm excited about Mirage This is one app you want to have in your photo enhancing arsenal.

MobileMonet: Sometimes you just want to play with your images. If that urge sweeps across you, just download MobileMonet (www.eastcoastpixels.com) and have at it. With control over line effects and paint-in image color, it's fun even if you don't use it for "serious" work (**4.15**). And always keep in mind that, if you like the effect but feel it's a bit too strong, you can always layer it with the original in Iris, Juxtaposer or FilterStorm to fine-tune the results.

4.15

![Tiny Planets icon] **Tiny Planets:** There are times when any semblance of "normal" in your images is the last thing you want. When you find yourself in one of those moods, Tiny Planet Photos is the medicine. Take a gander at **4.16** where you'll see the original shot of the white horse, the Tiny Planets options, and the final image. Choosing the Tiny Planet option means that the app wraps your image around the center of itself. Choosing the Tiny Tube option does the exact opposite.

![FilterStorm icon] **FilterStorm:** There's a good reason we'll use this app in the chapters on local image control and creative workflow. FilterStorm (www.filterstorm.com) works on both the iPhone and iPad and is rapidly becoming one of my favorite photo editing/enhancing apps. In fact, we'll spend more time with FilterStorm in the Workflow chapter.

4.16

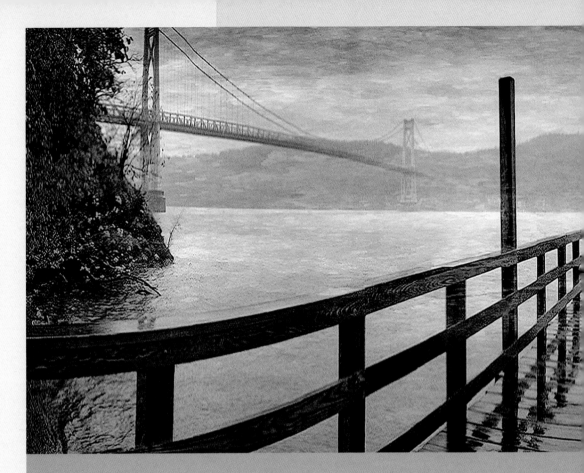

Chapter ⑤ Creating Panoramas with Stitching Apps

Sometimes the iPhone's standard, square-ish images just don't ring our visual bell. With a 3:4 aspect ratio (the ratio of the image's height to its width), the iPhone image shares a somewhat chunky shape, more like what we get from amateur point and shoot cameras than the longer and more graceful 2:3 aspect ratio of our DSLRs (digital single lens reflexes). Stitching lets us exert amazing control over the shape of our final image, whether our goal is to make a wide panorama (as in the "Two Bridges at Poughkeepsie" image) or to assemble extremely wide-angle views, as we'll explore below. The best news is that stitching a series of images on your iPhone is both easy and inexpensive. Let's dig in.

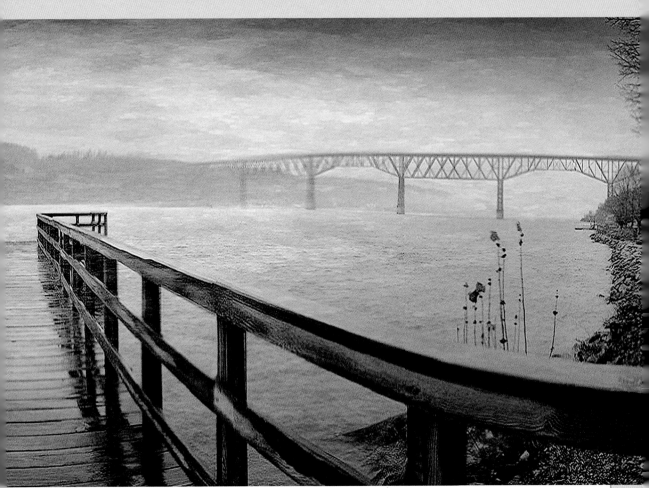

Two Bridges at Poughkeepsie

STITCHING IMAGES

For those who don't know, "stitching" is both a shooting technique and a software process. You shoot a series of images, carefully overlapping adjacent images a bit (we'll talk about how much shortly). This series can be in a single row (usually horizontal in orientation) or a grid, in which your series is comprised of both rows and columns of overlapping images. After shooting the series of overlapping images, we use software—or apps on the iPhone—to brilliantly combine (stitch) these individual frames into a continuous image that, ideally, shows no evidence of not having come from a single capture. The above image shows a single row stitch done with an iPhone 3G. In fact, everything done to this image was accomplished on the iPhone. These additional stylizing techniques will be covered in the Workflow chapter.

Note: Telltale evidence of stitching in the final image isn't necessarily a bad thing. Sometimes a bit of residual double-image artifact or irregular transition can be an intriguing feature in the final print.

5.1 *Using a Hand Image as a Series Bookmark*

A BASIC SINGLE-ROW STITCH

Let's look at a basic stitching job, this one using an iPhone 4, in **5.1**. I shot 16 separate images of the hammock between two trees.

Your first area of inquiry might be, "What's with the hand at the beginning and end of the series?" When shooting stitch jobs in the field, you'll often shoot more than one series of images. You might shoot one series from a different angle, or perhaps you'll do one with HDR and one without. When it comes time to select a particular series to stitch, it can be almost impossible to tell where one series ends and another starts. The shot of my hand serves as a bookmark to separate one series from the next. Momma didn't raise no fool after all!

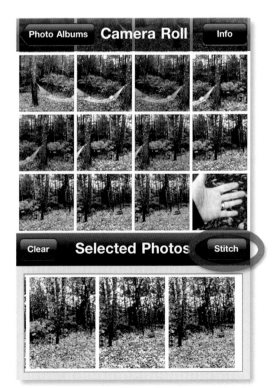

5.2 *Gathering Images to Stitch in AutoStitch*

 AutoStitch Panorama:: Get this app! Using AutoStitch for the first time is one of those "OMG" experiences. We needn't really say more in the way of recommendations; it's just one of the best photography apps in the App Store. The newest version of AutoStitch finally lets us shoot images from within the app itself. (Get used to the "update game." It's a rare day that 2-7 app updates don't appear on my iPhone.) AutoStitch will also keep an internal library of your stitched images, a feature that lets you reprocess the series at a later time.

When you first launch AutoStitch, you'll be presented with a window that lets you select the series you want to stitch into a single image, as seen in the left side of **5.2**. The golden fingerprint is my way of indicating how you tap each image to add it to the stitch group. If you're a fast tapper, AutoStitch will lag a bit behind in loading your selected images. Don't worry; they should load quickly. When all the images have loaded, the "Stitch" button will become active (circled in the right half of **5.2**). Tap this button to start the magic show.

Let's spend a moment with a couple of important options in AutoStitch. Sure, we adore resolution and firmly believe that more is better. The only problem with this set of beliefs is that when you start processing a bunch of images, the processor and RAM in the iPhone can get overtaxed. When this happens, AutoStitch will crash and you'll lose the time you spent gathering the series into the app. I can't give you a hard and fast rule because there are too many variables—from the original image sizes (2MP, 3MP, and 5MP, etc.) to the number of images you try to stitch at a time. The rule of thumb is, if AutoStitch crashes, lower the maximum resolution and/or change the Blending method to Standard instead of Best.

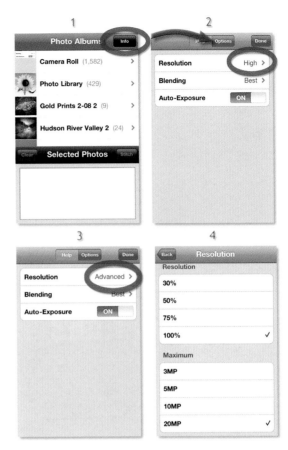

5.3

AutoStitch's Resolution and Blending Options: (1) Tapping the Info button in your main window takes you to (2) the AutoStitch Options (you can also access help by clicking the other tab). For the most control over final image size, choose Advanced. This will give you a list of file size options (4). You can limit your image by either percentages or by megapixels. If the app crashes (because you are using an iPhone 4 or later and/or you are stitching lots of images), try setting Resolution to 50% with a Maximum size of 5MP. It's not an exact science, so experiment.

5.4 *AutoStitch's Steps to Blend the Image Series*

AutoStitch goes through a series of steps as it calculates how to build your panorama. **5.4** shows the steps that are displayed at the bottom of your screen. (For the first four steps, to save space I'm showing just a clipped section of the screen image.)

Preparing Images: AutoStitch resizes the images to match the output parameters specified by the user.

Extracting Features: AutoStitch looks for subject details that are common in the series. Features detected in overlapping regions during this step are matched during the alignment stage.

Aligning Images: AutoStitch positions the individual images.

Rendering: The images are "built" into the final composite.

Rendering Visually: Here you see the image form. The size of the tiles vary depending on which Blending method you've chosen in Options (**5.3**).

If your image is in landscape orientation, rotate your iPhone to see it more completely.

Your image will always have raggedy edges after the stitching process is complete, so let's go through the cropping steps that are the next logical move.

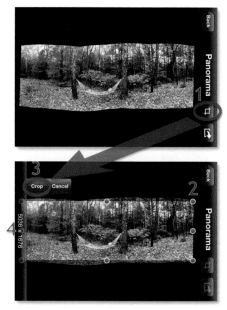

5.5 *AutoStitch Cropping in Landscape Mode*

Note: Occasionally, you might want to save an uncropped image from AutoStitch. When might this occasion pop up? A typical example is when your image's horizon is tilted; having some extra image space might come in handy with you perform an image rotation in another app. Perhaps a future update of AutoStitch will allow for rotational crops.

Tapping the Crop icon (1 in **5.5**) will place a cropping guide over your image. AutoStitch will position the crop conservatively, so as to eliminate the scalloped edges but leaving as much of your image as possible. If you want to modify the crop, drag the "handles" (blue dots) to any position you like. When you have the crop handles positioned where you like them, tap the crop button. AutoStitch displays the pixel dimensions as you move the crop handles.

After cropping it's time to save your creation. AutoStitch gives you handy options as shown in **5.6**.

5.6 *Saving Options in AutoStitch*

A common question is how much should you overlap between exposures. It is, after all, this overlap that gives our stitching app the information it needs to assemble the series of images into a panorama or multi-row stitched image. Camera experts suggest around 30% overlap from frame to frame. I overlap much more than 30%. Heck, my overlap is more like 50%. Why would I do such a thing? Doesn't this result in too many images that take precious space on our iPhones and then also take much longer to stitch? There's no doubt about the space and processing time issues; more images will always take more space and thus take longer to process. But one of my personal digital guiding lights has been to give plenty of information to the software. The more data the software is given, the better it can do its job—stitching in this case—when assembling the final image. But as always, the best advice is to run your own tests rather than believing me or anyone else. If a smaller overlap works for you, then that's the way you should shoot.

Pano: AutoStitch isn't the only app for stitching on the iPhone. Pano (www.debaclesoftware.com) can make up to 360° panoramas from up to 16 images. Pano also offers a semi-transparent, onionskin-like overlay effect to help with your image-to-image alignment. As nice as Pano is, don't forget that this is a single-row stitching app so don't plan on creating multi-row images. Pano has a maximum final image size of 800 x 6800 pixels.

MULTI-ROW STITCHING

The hammock example above was a typical single-row panorama. To show how AutoStitch handles a multi-row stitch, let's take a gander at **5.7**.

For this 15-image stitch, there's no need to show all of the AutoStitch steps, for the simple reason that they're the same as a single row panorama. **5.8** shows the uncropped and the cropped final version made from two rows of images.

5.7

5.8

STITCHING WITH THE iPHONE 4 & 4S

Good friend and excellent photographer, José Maria Mellado, once advised that stitching with lenses wider than 35mm (on a full-sized sensor DSLR) was ill advised because of the way wide-angle lenses "pull" at the corners. For example, if we shoot with a 24mm lens, the stretched corners in each individual image present problems for the stitching software as it attempts to align the overlapping images.

The same advice applies when we stitch our iPhone images. Back in the iPhone Hardware chapter, we noted the effective focal length of the first three iPhone models was approximately 37mm. With the iPhone 4 and 4S, Apple went wider with the optics, creating an effective focal length of 28mm. This wider lens might make for a bit more difficulty in stitching images owing to that corner pulling that José Maria observed. Remember, this wide-angle stitching problem only occurs when you have both near and far object in your photos; if you're stitching a scene that is distant, even the iPhone 4 images should meld together seamlessly.

Even if you've never been a fan of stitching with Photoshop, you owe it to yourself to experiment with the iPhone's incredible stitching capabilities. And don't be shy: Try exotic stitches that run from the ground right at your feet all the way to overhead tree branches. That magical sense of space and visual intrigue is just an overlapped series of images away.

● STITCHING WITH THE iPHONE 3G

The touch to focus feature has big advantages in the stitching department too. Being able to bias exposures for highlights and shadows is helpful in guaranteeing good tonality in shadows, highlights, and midtones. But stitching with a 3G or original Silverback can actually help the final print's tonality.

Think about it this way: As you overlap your frames, the camera's auto exposure system is adjusting shutter speed and ISO to give a "good" exposure. Your series will encompass dark and light areas, so when you stitch them together, AutoStitch blends these different exposures, in effect generating a quasi-HDR effect. Many of my best stitches were done using just this "overlapping exposures" technique.

A Stitched HDR Image Using Pro HDR

Dynamic range is the range of tones in a scene from the darkest shadows to the brightest highlights. Research has found that, for most of the photos we take, viewers find them more visually pleasing if there is tonality in all regions, rather than empty blacks and pure white area. HDR—or High Dynamic Range—in its truest sense is a combination of shooting techniques and software processing that produces a more tonally complete final image. True HDR starts with multiple exposures of the same scene (usually three exposures: normal, dark, light) that are combined via software to produce the tonally rich final image.

Chapter ⑥ High Dynamic Range Imaging

● HDR APPS

Let's start off by outlining the HDR options on your iPhone. You have three choices: Apple's built-in HDR function (iPhone 4 and later) that takes three exposures and then blends them into an HDR image; 3rd party apps that take two exposures and blend them automatically or with input from the user; and apps that perform pseudo-HDR processing on a single exposure, attempting to mimic a multi-exposure HDR image.

The first two options are the "real" HDR processing tools for iPhones. In fact, we're not going to discuss that third category of apps that fudge an HDR look from one exposure. Though they may occasionally apply an interesting, stylized look to your image, as HDR tools, they are inferior and merit no further discussion. Harrumph!

Note: **My book,** *The Color of Loss: an Intimate Portrait of New Orleans after Katrina* **(University of Texas Press, 2008), was the first coffee table book photographed entirely with HDR techniques. I didn't use an iPhone because it hadn't been invented when I photographed in New Orleans back in early 2006. (This is just to establish my credentials with HDR photography, considering there are so many approaches, theories, and tastes of what constitutes good HDR work.)**

Note: Apple's built-in HDR, available with the iPhone 4 and later, changes all the rules. We no longer have to purchase additional apps to do HDR photography. That doesn't necessarily mean you shouldn't buy additional HDR apps, as you'll read about below. .

6.1 *Settings to Save the Normal Exposure along with the HDR Image*

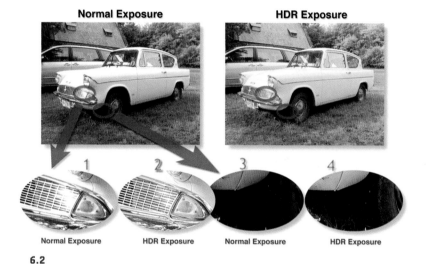

6.2

APPLE'S HDR

Apple's built-in HDR—we'll call it Apple's HDR for simplicity—takes three exposures very rapidly and automatically saves the final processed HDR image to your camera roll. A setting (under Settings>Photos) allows you to save just the final HDR exposure or both the normal and HDR versions. It's best to save your normal exposure too; you might find that normal exposure better than the HDR in some cases. **6.1** shows the Settings page and where you can opt to save, or not save, the normal exposure.

6.2 illustrates Apple's HDR feature at work. Examine the blown-up areas from both the normal exposure and the HDR version. First we'll compare the highlight rendition (1 and 2 in 6.2) In the normal exposure, the Anglia's grill (a British compact car from the 1960's) has highlights that are completely blown out. By comparison, the HDR exposure has much better highlight retention, not only in the bright, metallic grill but also in the car's paint above the grill.

The shadow comparison is less dramatic, though still worth noting. It's almost impossible to discern tire tread detail in the normal exposure, whereas the HDR shot reveals the tread pattern and even blades of grass in the shadows. These results — better highlight details without big gains in the shadows — seem fairly typical for Apple's HDR feature; it favors highlight detail over shadow openness. If Apple had to favor one or the other, this was a good way to go since we can often open the shadows with levels, curves, or shadow/highlight controls in our editing apps.

When to Use it: Apple's HDR works well for landscape photography where high contrast scenes are common. It's not good if you are shooting a moving subject; though it is fast at making those three exposures, a quickly moving subject will be rendered with motion. (Keep in mind that all of the other HDR apps are even slower than Apple's HDR and will result in pronounced ghost images when subject motion is present.) And because your iPhone will turn off the flash in HDR shooting mode, subjects that need that extra pop from the iPhone's LED flash will turn out disappointing.

A plus for Apple's HDR is that you do have access to the camera's digital zoom feature, something that 3rd party HDR apps have omitted. And yes, though you can accomplish the same effect as digital zoom by cropping in an editing app, sometimes it's faster to capture the image as you want it right on the spot.

Hint: You can fine-tune Apple's HDR image exposure by focusing on dark or light tones in the scene. After all, the 3GS (and later) not only focuses where you tap on the screen, it also bases its exposure on that area of the image too. Look at 6.2 to see how we can use this feature to affect the final HDR image.

Normal Exposure

HDR Auto Focus

1: This image shows the iPhone 4's normal exposure. Like many scenes with higher contrast, the highlights are burned out and the shadows are darker than we'd prefer. For this shot of Kaaterskill Falls, I let the iPhone focus at its default center area.

2: Using the same default focus/meter as the first image, this second image shows the HDR shot produced with Apple's HDR. The waterfall has much better detail but the shadows are still very dark.

HDR Focus on Dark Tones

HDR Focus on Light Tones

3: Here, I tapped on a dark part of the scene (like the foliage in the lower left) to bias the camera's meter toward a lighter exposure. Apple's HDR still maintained detail in the falls admirably while opening up shadow detail better.

4: Finally, I focused (and metered) off the bright sky area at the top of the frame. The HDR image does have more highlight detail, but the shadows are hopelessly dark.

6.3

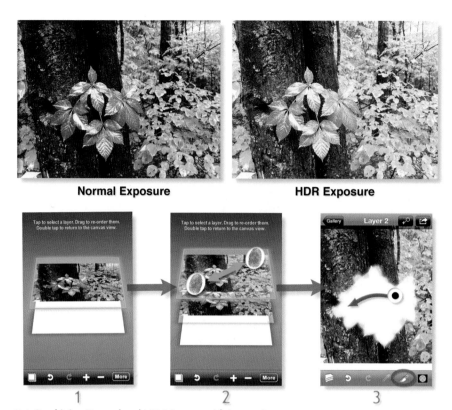

Normal Exposure **HDR Exposure**

1 2 3

6.4 *Combining Normal and HDR images with Layers App*

LAYERING APPS

My first iPhone was the 3G. Though a wonder for its time, the camera was handicapped in terms of resolution, as well as focus and exposure control. Basically, you had no control at all; you composed your shot and hit the shutter button. And 3rd party apps (like Pro HDR; more on that in this chapter) didn't work with the 3G either. So what to do?

Stitching to the rescue! Yes, all the goodies you learned in the last chapter can be used for HDR too. By overlapping your individual exposures to create a multi-row panorama, you can blend exposures to create a final stitched image with better tonality in the highlights and shadows.

As good as Apple's built-in HDR capture is, it can sometimes create an unnatural tonality or make lighter midtones too bright, as in **6.4**. The iPhone's "normal" image has richer, more saturated tones in the red leaves, but this comes at the cost of shadow detail. Even the normal shot — on an overcast day, no less — still had too much dynamic range for the iPhone's camera Now look at the HDR version. The shadows are much more inviting, but the star of our image— the red leaves—have been rendered too light and lifeless. Wouldn't it be swell if we could combine the best of both? Of course! Let's see how we do that right on our iPhone.

iPhone Artistry

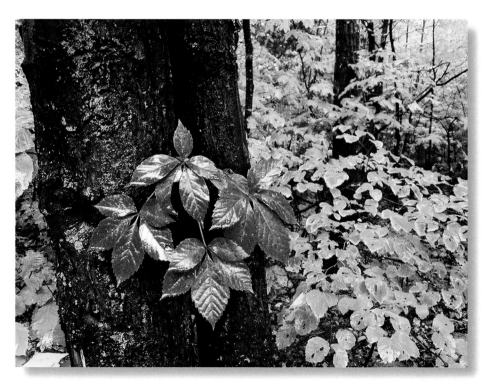

6.5 *Final Combined Image*

Layers: Let's apply what I call the "logic of Photoshop" to iPhone photography. It's like asking, WWPSD: What would Photoshop do? In case you haven't guessed, Photoshop would be the perfect place for combining the best of these two images with—are you ready?—layers. Fortunately, we have access to layers on our iPhones, too. Let's take a look at how I combined two exposures in Layers (www.layersforiphone.com), one of several excellent apps that bring layer functionality to our iPhones. (We go deeper into Layers in the Workflow chapter.)

6.4 shows two images I shot on a rainy fall morning near my house. With the iPhone set to its native HDR, it quickly saved the normal exposure (on the left) and the HDR image (on the right). The normal exposure looked better than the HDR image in this case. The only thing I didn't like about the normal exposure was the missing shadow detail in the tree trunk.

6.4 shows a truncated version of my workflow using Layers. In the first screen shot (1), I opened the normal exposure in Layers. This is via the + menu at the bottom of the screen. In the second screen shot (2), I loaded the HDR image into its own layer, on top of the normal image. Next I zoomed into the image with the two-finger reverse pinch so I'd have more control over my next step (3): erasing the washed-out red leaves in the HDR image. I used the brush eraser tool to erase away the parts of the HDR image that I don't want to see in the final composite. **6.5** shows the final combined image: bright red leaves combined with better shadow detail in the tree's trunk.

OTHER HDR APPS

While the speed and convenience of Apple's HDR is commendable, there are other HDR apps that, though not as fast, offer some very inviting control over shooting and processing your images.

6.6 *Pro HDR's Splash Screen and Settings*

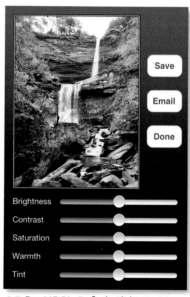

6.7 *Pro HDR's Default Slider Positions*

Pro HDR: Pro HDR is my favorite HDR program for situations in which Apple's HDR doesn't quite do the job. Unlike Apple's HDR, which uses three different exposures to blend into the final HDR version, Pro HDR uses two images: one underexposed image and one overexposed image. No one trick pony, this app provides several ways to shoot HDR. The left half of **6.6** shows you the app's splash screen, which is where you make your first decision on how to do your HDR. The right half shows the settings screen, where you find important stuff like the settings for the

image size you want saved to your camera roll. I've circled the large setting because it's hard to imagine why you'd make the effort to get better tonality just to throw away pixels. There's also a choice for the size of emailed images. Note this refers to images you email directly from Pro HDR.

The three methods offered by Pro HDR— Auto HDR, Manual HDR, and Library HDR— all have their place. Cutting to the chase, the Auto HDR method is really amazing (and frankly, the easiest), especially if you can work with a tripod. In Auto HDR mode the app

analyzes the scene, makes two exposures, and aligns and blends the exposures into the HDR image. If you have the automatic sliders turned on, Pro HDR will move the adjustment sliders to give what it considers the best results for the scene. With the automatic sliders turned off, your image will be processed with the sliders at their default values as in **6.7**.

Pro HDR's Manual method provides a bit more control by letting you designate both the bright area and dark area of your image. This can be helpful for scenes with extreme contrast where the very darkest part of the image isn't the best choice for preserving detail.

The Library HDR method lets you choose two images from one of your iPhone photo libraries. This method of delayed processing is especially handy when you've used another app to capture the light and dark exposures that are saved to your camera roll.

Note: Pro HDR gives you the option to save just the final HDR image to your camera roll, or all three images (dark exposure, light exposure, and the final HDR composite). There's no right or wrong decision here; if you think you might want to work with either or both of the two building-block exposures (with layering, for example), then turn on the Save Original Images option (in 6.6); if you're short of storage space or never need those dark and light images, then turn this option off.

GET STEADY

You might be thinking, "If I'm going to carry a tripod I'll put a real camera on it instead of an iPhone." Before you dismiss the entire tripod idea, remember that your iPhone can be supported using small, lightweight tripods that would never be safe for your DSLR. And you don't have to use a tripod; holding the camera very still during the two exposures can result in nicely aligned images. Still, using a tripod can be a big help in improving image quality, especially for HDR images with your iPhone.

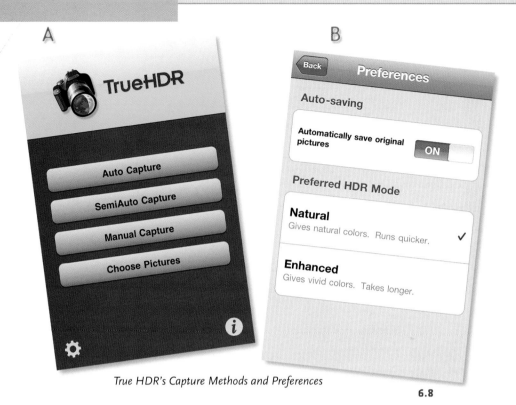

A

B

True HDR's Capture Methods and Preferences

6.8

True HDR: True HDR is the name of an app, not the description of a method—and a good app it is! Though True HDR started out as a phony HDR tool—using just one exposure to fudge an HDR look—it has undergone terrific updates that bring real multi-exposure HDR capability to the iPhone. **6.8** shows the splash screen and preferences for True HDR. Notice that True HDR, like Pro HDR, offers several ways to shoot your HDR scene. Let's look at the options.

Auto Capture: Auto Capture works much like Pro HDR's Auto HDR mode. With one tap, the app takes three pictures (one used for the brightness evaluation, not the actual HDR processing) and melds them together.

SemiAuto Capture: Here, True HDR starts to show its colors. An on-screen prompt directs you to tap on a bright and dark area in the scene. Though the app's help section mentions tapping on a dark area of the scene first, in use it doesn't seem to matter whether you first tap a dark or light region. The camera then takes two pictures and does its melding magic in a very convincing manner. This method is quite good, often producing images with less noise and better shadow detail than Pro HDR. The camera takes the light and dark exposures very quickly, so there is less chance for image registration issues (how the images line up).

Manual Capture: This method is similar to SemiAuto, except you manually take each picture after selecting the light and dark regions of your image. The advantage to this method is that you see the effect when you individually set the bright and dark points; this visual feedback lets you move the points for better results before you tap the shutter button.

Choose Pictures: Here you can select two images (one dark, one light) that you've taken with another camera app.

True HDR offers an interesting option in Preferences (see B in **6.8**) for Natural or Enhanced color. Enhanced will give more of a "grunge" look with more color punch. Also, you might notice that True HDR crops into your image a bit more than Pro HDR. If you've included important subject detail near the edges of your image, Pro HDR might be a better choice for your HDR processing.

> Note: Remember, you don't have to make a solid decision on which way to shoot and process your HDR images. You can shoot the scene more than one way to learn which app does the best job. This playful experimentation can be a great education.

GET SHARP

I mentioned above that Apple's HDR is much faster than the competition in shooting and then combining the three separate captures (even though the other apps use just two exposures for HDR rather than three like Apple's HDR). This has an advantage in more than saving time; your image sharpness can be improved—especially in low light—with the Apple's rapid shooting. 6.9 shows a comparison in which camera movement played a roll in final HDR image sharpness.

Apple's HDR

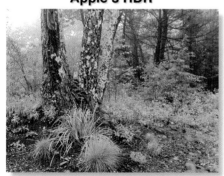

Pro HDR (Manual Method)

Better Sharpness

Less Sharpness

6.9 *Low Shutter Speed Sharpness with Apple's HDR and Pro HDR*

WHEN TIME IS SHORT

With the exception of Apple's HDR, all other formal HDR apps take a bit of time to capture and process the images and then to save the final, tonally enriched HDR image to your iPhone's camera roll. But what if you need to work quickly, with not enough time to futz with a proper HDR app? One situation that comes to mind is when you want to combine HDR capture with panorama stitching. Trying to shoot and process a whole series of overlapping HDR images can be a tiring ordeal. Well, there's a simple solution to just this dilemma.

Bracket Mode: Let's take a look at how Bracket Mode quickly creates two exposures (dark and light) that can be combined later for HDR processing.

6.10 shows how Bracket Mode automatically places metering points at the darkest and lightest areas of the image. These points are movable, so if you feel that a different location is better for your exposure, you can relocate it by dragging with your finger. When the metering points are located to your satisfaction (three out of four times, the default locator works just fine), tap the shutter button and the app takes the two exposures quickly. I recommend that you configure Bracket Mode's settings to Auto Save the images; this speeds up the shoot-and-save routine, which is especially helpful when you are shooting lots of images and time is of the essence. The Bracket Mode app makes capturing your dark and light exposures simple; you may find that your HDR iPhone photography becomes even more fluid and precise.

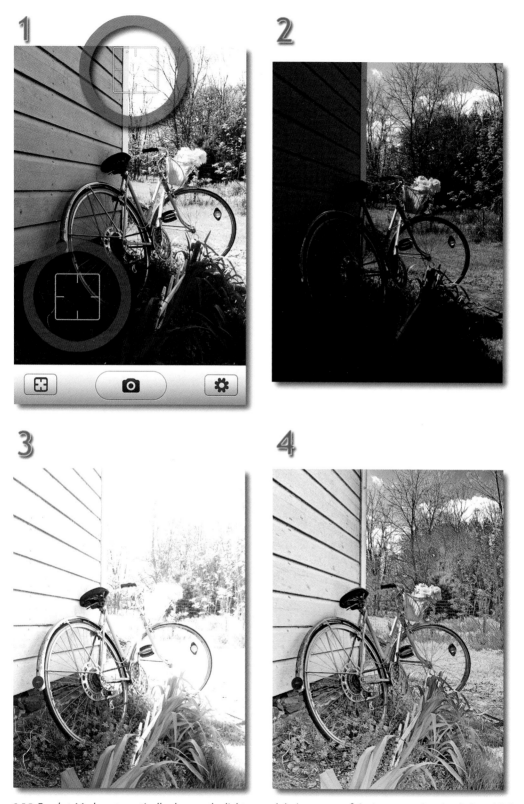

6.10 Bracket Mode automatically chooses the lightest and darkest areas of the image, makes the dark and light exposures, and then saves them to the camera roll. The last panel (4) shows the final HDR image that was processed later with one of the HDR apps.

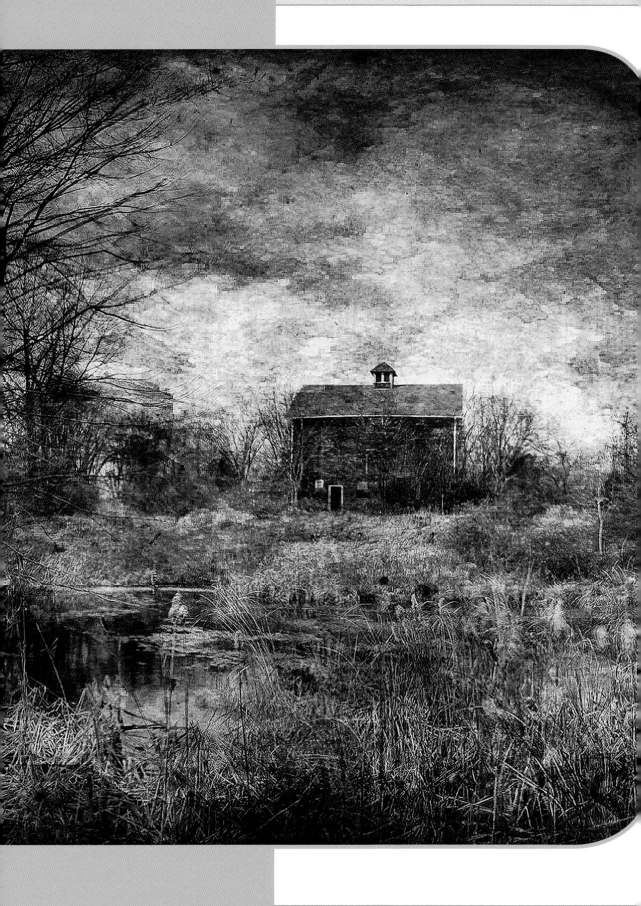

It's darn rare that we encounter an image on our desk-bound (or lap-bound) computers that doesn't have a dust speck, an artifact, or some other unwelcome visual visitor that needs to be removed. So it is with our iPhone images, too. Advanced image editing apps mimic many of the sophisticated imaging tools digital photographers have currently in their digital darkroom – like cloning, retouching, and sharpening – so that polishing iPhone images is just as accessible.

Chapter ⑦ Advanced Image Editing

● RETOUCHING

By now, Adobe software users recognize that many of our iPhone editing tasks closely parallel tools and techniques used in Photoshop. Retouching involves the clone stamp tool and the healing brush, and you can find similar apps on your iPhone that perform these functions. Overall, the healing brush is a better retouching tool for most images. Should you find that the healing brush is "sucking in" too much adjacent tone or texture (when healing spots near a dark border effect, for instance), try retouching with the clone stamp instead.

Several popular apps provide cloning capability to take care of "normal" retouching. Rather than go through a long list of virtues for numerous apps, let's discuss those that have the best interface and best algorithms for cloning and retouching.

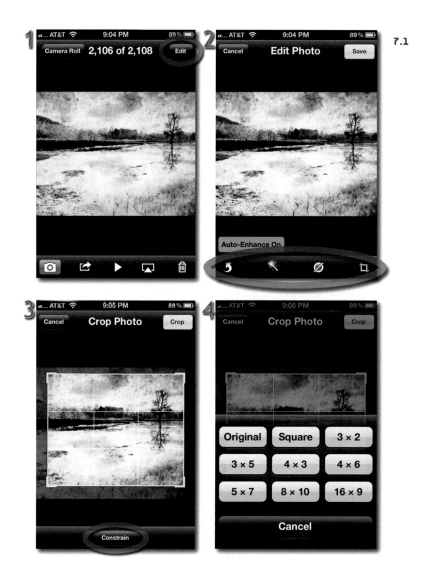

Retouching in the Camera Roll: With the introduction of iOS5, iPhone users have access to valuable retouching features without the need to purchase additional 3rd party apps. **7.1** illustrates a few useful editing tools available on the iPhone 3GS and later.

Tap the image in the Camera Roll to get access to the Edit button in the upper right (1). Four editing tools appear at the bottom of your LCD: Rotate, Auto-Enhance, Red-Eye Reduction and Crop (2). Cropping can be performed free form, or it can be set to a specific aspect ratio via Constrain (3) – a full range of aspect ratio constraints is available.

Every edit you apply here are stored as edit instructions, much like the way Adobe Camera Raw or Lightroom stores edits. You can return to an edited image in the camera roll at any time to change or remove the edits.

iPhone Artistry

CLONING

Photo fx: I won't go on too enthusiastically about Photo fx in this chapter since we covered it in full in Chapter 3. Suffice it to say that Tiffen—a company famous for camera filters—knows a thing or two about photography in general and app development in particular. Photo fx does lots of things well, but let's look at this app's approach to cloning.

7.2 shows the Photo fx effect selection screen. In the scrollable list of categories at the bottom, I've selected "Image" (highlighted in blue)

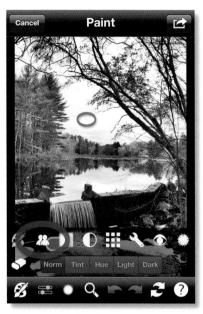

7.3 *Choosing the Clone Option*

Clicking on the Paint icon brings up the screen in **7.3** in which we'll choose the Clone option. (By the way, our goal in this example is to retouch out that nasty cloud that's also marked with red in **7.3**.)

Next we choose the cloning brush size, harness and opacity as in **7.4**. When adjusting the brush options, Photo fx provides a preview of the brush size and shape in the lower right of the screen (**7.4**).

7.2 *Photo fx's Painting Option*

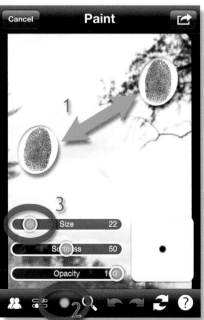

7.4 *Zooming in with a reverse pinch makes cloning easier. Clicking the Brush icon brings up the brush options, including, softness and opacity.*

7.5 *Setting the Clone Source with Tap-Hold-Drag*

You use a tap-hold-drag action to set your cloning source (**7.5**). When you tap and hold, you get a bright green indication (of your cloning source point) that's hard to miss. If your first tap isn't in the right place as a clone source, a double-tap resets the clone tool. In **7.6** the offending cloud is gone.

7.6 *Cloud Removed in the Sky; Help is Always Available*

HEALING

TouchRetouch: If you're familiar with Photoshop's healing brush, you will feel right at home with TouchRetouch (www.iphotomania.com). Unlike cloning, which duplicates detail from one area of your image into another, TouchRetouch eliminates objects, people, power lines, etc. from your image by intelligently replicating the surrounding detail. It's easier to demonstrate than to explain, so let's remove the nasty floodlight in the lower left of **7.8** with TouchRetouch.

7.7 *TouchRetouch's Splash Screen and Resolution Selection*

When you first open TouchRetouch, you're given a choice of resolutions with an accompanying warning that higher resolution images take longer to process. If you're trying to do serious photographic work with your iPhone (and if you're reading this book that should be a fairly safe assumption), then go with the original resolution, in this case 2592 x 1936. But take a gander at the maximum resolution above the native resolution for the image (circled in red). That's right: You can retouch images up to 20 MP size. (Why would you want to do this? Don't forget that AutoStitch provides for creating images up to 18 MP in size.)

7.8 *Zooming-In and Choosing a Brush Size*

Note: If cloning is what your image requires, TouchRetouch has a cloning tool, too.

Once you've selected a resolution, your image opens as on the left in **7.8**. The flood light in the lower left is the object that is to be banished from the scene. First, I zoom in (**7.8**). Touch Retouch gives us two different ways to select objects or areas. We can lasso or paint over them. The final results are the same, so the method you use is a matter of personal choice. As a fan of masking, I'm more prone to use the brush tool, as highlighted in **7.8**. Moving the slider to the right increases the brush size; note that TouchRetouch gives you a nice brush preview in the middle of the screen. Unless you want to fine-tune your brushing with the eraser tool, it's better to use a smaller brush that won't give you a lot of overspray.

On the left of **7.9** you can see how I've painted over the flood light. You don't have to be exact. In fact, notice that my painting over the light is far from perfect with an extra glob of paint in the upper left corner. Once you have the area defined via either the brush or lasso, click the Go! Button and watch as the object magically disappears.

If the retouch doesn't meet your expectations, simply tap Undo and fine-tune your selection. **7.10** shows the final retouched image; the only thing remaining is to save the image by clicking the disk button in the lower right. TouchRetouch can save you loads of time compared to carefully cloning over unwanted details.

7.9 *Defining the Area to be Retouched with the Brush*

7.10 *Saving the Final Retouched Image*

CONTENT AWARE SCALING

If you're like me, some of the iPhone apps are so amazing – especially considering the price – that I get a tingle just thinking about them! This next app is one of those tingle-inducers so let's dig in.

Liquid Scale: Did you ever make an image that had too much open space between important subject matter? Like a couple sitting too far apart, or a forest yeti who's separated from an adjacent tree just a bit too much? Yes, it happens to me, too. Not to worry; Liquid Scale (www. savoysoftware.com) is a super-intelligent filter that performs content aware scaling on your image. You can now close up those unsightly gaps in your otherwise perfect compositions.

Liquid Scale is a bit like our old Photoshop friend, the Extract filter (which has since moved on to greener pastures as it's no longer included with Photoshop), because in both we designate areas of the image to keep, and the areas that can be sacrificed during the scaling process. In short, it's as close to magic as you can come without changing religions.

7.11 *Defining Areas to Keep and Areas to Remove in Liquid S*

When you first open your image in Liquid Scale, it will look like screen 1 in **7.11**. You can see why we need to close up that awkward space between the tree on the left and the one the yeti is hiding behind (this is our yard by the way). When you tap the screen, you are presented with the three icons circled (2). The green + (plus) is used to paint over areas that should be protected, and show up as green selections. Paint anything you want to keep in the image green so it doesn't get removed during the scaling process.

The red – (minus) is used — you're probably ahead of me already — to paint red over the areas that can be removed during scaling. Were we doing this in certain cultures we'd refer to them as sacrificial subject areas.

The X is an eraser tool that's used to clean up either green or red if your painting has gone a bit astray. In **7.11** I've protected the tree on the left, the yeti, the tree on the right, and it only seemed right to protect the log pile where the yeti is hiding. I want to banish a big swath down the center of the image. This is really easy: green stuff in your image will stay and red stuff will disappear.

iPhone Artistry

When you have your red and green parts painted the way that makes sense (given your scaling goals), tap Done in the lower-right corner of the screen. Be patient; it takes a few moments to encode your image before you can actually scale it. During the encoding process you'll see hotdog shaped gray bars grow from the bottom corner of your image to the center. When they meet, you are ready to scale.

When you are ready to scale the image, grab the triangular handle (**7.12**) and drag it toward the center of the image. As you do – and this is pretty cool – the area that is being compressed displays a pattern of crazy lightening bolts. Another neat thing that Liquid Scale does as you transform the image is show the resultant pixel dimensions (top center in screen 1). Stop dragging the handle when the image is scaled to your liking. You can scale in either a vertical or horizontal axis too.

The one dirty secret of Liquid Scale is that your resolution is compromised. You can minimize this by going to Settings in Liquid Scale and choosing High resolution.

1

The yeti and his adjacent tree are arranged much better now (2) . The rectangular image is now a square but there is no "squeezing" of either the yeti or the tree on the left. Amazing isn't it!

Did I mention that you can also use Liquid Scale to stretch an image? And of course the stretching is done in a way that does not distort important subject matter, assuming you've been proficient with your greens and reds. Try it!

2

7.12 *Moving the Scaling Handles to Close Up the Extra Space*

● SHARPENING

We've covered the camera apps we use to capture the image, exposure adjustment apps, and cropping essentials. Now it's time to sharpen the image.

There are many choices when it comes to sharpening images on our iPhones. And just like with the abundance of sharpening choices in Photoshop (Sharpen, Sharpen Edges, Sharpen More, Smart Sharpen, Unsharp Mask), they are not all created equal. Let's look at two of my favorite sharpening methods on the iPhone. One of them gives great visual feedback; the other gives greater control via advanced settings.

Perfect Photo: Perfect Photo, in addition to being a strong cropping tool, makes your sharpening life easy. It does this in two ways: by giving you a simple, one-slider control and by automatically showing your sharpening effect in a very handsome with-and-without format. Let's walk through the steps of sharpening with Perfect Photo in example **7.13**.

(1) After loading your image into Perfect Photo, tap the Tools icon in the upper right. (2) Scroll down to Sharpen, making sure you're in the Tools section and not Effects. (3) When your image comes up, it shows a non-magnified view. (4) As soon as you move the Sharpen Amount slider, you get the comparison view. My normal sharpening amounts are between 25 and 45. (5) If you apply too much sharpening, the image becomes grainy with noise and halo effects. (6) When you're satisfied with the saturation level, click Apply (the check mark at the top of the screen). You are presented with an "Amazing Fact" during the processing step that disappears as soon as sharpening is complete.

After you've examined your sharpened image, you're ready to save it to the camera roll so you can take it to the next app for further enhancement (**7.14**).

Note: The sharpening we do on our iPhone should be considered pre-sharpening, much like the sharpening we do in Lightroom or Adobe Camera Raw. This is different from the final sharpening right before printing. And, if you plan to apply blur filters to your image, you probably don't want to sharpen at all.

7.13

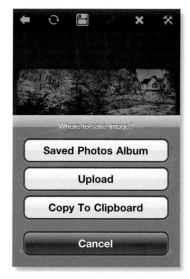

7.14

1 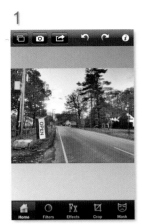 **2** **3**

4 **5** 7.15

 Photo Wizard-Editor: PhotoWizard is a powerhouse of useful features plus an exceptional interface design. In fact, it's so good that you'll hear more about it in upcoming chapters. For now, look at its sharpening skills so you can get the best results as you sharpen your images. **7.15** walks through the steps.

(1) Sharpening is considered a filter effect, so tapping Filter at the bottom of the screen brings up a list of all the different filter effects that are available. (2) Note that both Sharpen and Unsharp Mask are listed. Just like in Photoshop, Unsharp Mask gives us more control. (3) The same three sliders as in Photoshop (Radius, Amount, and Threshold) are available to make adjustments. It takes some practice to get the settings just right because you cannot zoom the image when sharpening. (We'll see a way to critically evaluate the image for the proper amount of sharpening soon.) Click the check mark in the upper right to apply sharpening. (4) When you return to the Home screen (lower left) you can zoom in to accurately evaluate the sharpening results – this is the sharpened version. (5) Handy Undo/Redo buttons let you do easy with and without comparisons. Better yet, swipe left to Undo and right to Redo your sharpening. This also works for any filter you apply, making it very easy to evaluate the effect applied.

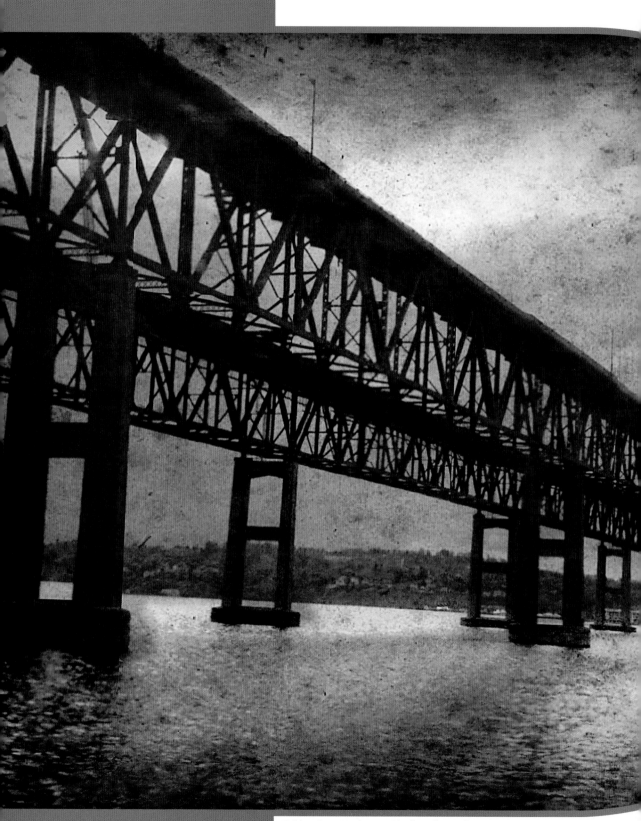

Bridge Over Hudson, a Single Enhanced Exposure

Chapter ⑧ Layering Apps

The technique of layering is a great tool for combining images. Suppose you want to place a better sky into an otherwise perfect landscape; layers make the task a simple one as you load the better sky image as a separate layer on top of your foreground image. This layering concept allows separate components of an image to maintain their own identity. Once that sky is in place, for example, it's easy to move it or change the layer opacity to make the sky more or less prominent. Better yet, using layers lets you play with different effects in your compositing. Digital geeks call this "non-destructive" image editing. I call it a fear of commitment, which is a good thing in photography (though maybe not in your personal life). No matter what you call it, using layers adds both power and the ability to change your mind to your iPhone image-editing workflow.

SIMPLE LAYERING

The first step to layering is to create the various layers that you want to use. Remember this example (**8.1**) of Trudie from Chapter 4? It was the first look at creating images that can be used as layers. Here, I used ToonPaint to create a sketch of an image.

When creating layers, use the best resolution possible (**8.2**). High Resolution is what we want for the best image quality (1). 3MP is the maximum possible image size with this app. If you've taken advantage of ToonPaint's color painting features, you should save as MagiSketch + Paint. Because I did no painting in this stylized photo of Trudie, I'm saving as MagiSketch only. (2) Next I use the Layers app with the ToonPaint version on the top Layer (selected in blue) and the original image on the bottom layer. Notice the transparency slider is adjusted to about 50% (circled in red). Once the two layers are combined, the final image displays both texture and the color and detail from the original iPhone photo.

8.1

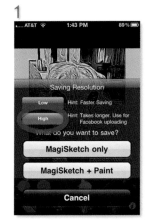

8.2

iPhone Artistry

IN-DEPTH LAYER CONTROL

Iris Photo Suite: Apps that provide layers offer the best way to control how much each "part" of an image contributes to the final image. To drive home the power of layers on our iPhones, here is another photo app with in-depth layer control (we'll revisit Layers to cover its options more thoroughly). The more I use Iris Photo Suite (IPS) the more I like it. It's a comprehensive basic editing app (lacking only curves), but it has the ability to add textures and layers to your iPhone images. **8.3** walks through the texture paces.

As we see in **8.3**, the trade off in Iris Photo Suite is one of texture vs. resolution. But you don't have to sacrifice your precious pixels in order to apply beautiful textures to your iPhone images. You can have the best of both worlds. Iris includes a powerful layers engine that will let you apply textures at full resolution. Let's look at the steps involved in creating a full-resolution textured image.

Iris Photo Suite's Textures: Load your image into the IPS app. Tapping on the Actions button (lower right) brings up the Textures screen. Notice the warning. If you use IPS's included textures, your output resolution is limited to 1200 x 1600 pixels. Another way to look at this is that you are turning your iPhone 4 into an iPhone 3G. There is a workaround we'll discuss shortly. Tapping OK (as if you had a choice) brings up the Textures window where you can choose from nine

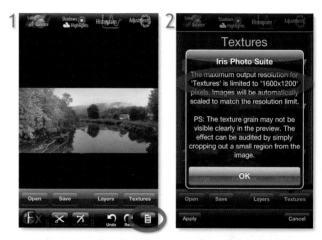

8.3

different textures. The variety is pretty nice; in this example I'm choosing Grunge. Clicking the Apply button takes you to the next screen where you see the texture applied. Best of all, you can fine-tune the amount of texture with the slider at the bottom of the screen. When you have your image looking the way you like it, tap Apply. Then you can click the Actions button to save your complete image.

8.4

VintageScene: As we saw in Chapter 4, VintageScene can be used to create layers that you might want to add to a composite. One of the great things is that you can save it as a preset that can be applied to future images. **8.4** is the same example from earlier - instead of applying the texture to an actual image with elements, I photographed a white wall so that I have just the texture itself. I can save this (**8.5**) and use it as a layer with any of my other images to build a unique and interesting composite.

~~Iris~~ Photo Suite's Resolution: To apply a full resolution texture you first need a full resolution texture. That's easy enough. For **8.4** I photographed a white wall with the iPhone to create a "canvas" upon which I could build a texture. That of course leads to the question, what app will create the texture? The answer is "many" but I used VintageScene in an earlier chapter because of it's complete set of textures and vignettes.

Your image has been saved to the camera roll.

OK

8.5

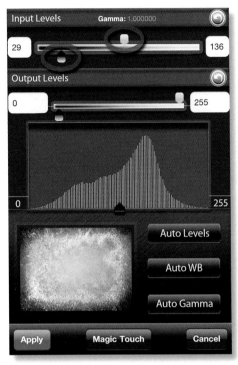

8.6 *Adjusting the Texture's Contrast with Iris Photo Suite*

⊦HECKING RESOLUTION

⸻e whole point of this exercise is to use Iris Photo ⸻uite (IPS) to build a full resolution, textured image. ⸻t's check the size of the texture we just saved ⸻om VintageScene to make sure we aren't going ⸻to IPS with less than ideal resolution. The perfect ⸻p for this size check is PhotoSize; there isn't a ⸻ster or simpler way to perform a resolution check. ⸻hotoSize confirms that all of our resolution from ⸻e iPhone is saved in our texture file. Yes, we do ⸻ave to endure the ad at the bottom of PhotoSize's ⸻creen. After all, this great app is free.

Now let's go into IPS and actually work with that nice texture file. First, let's fix that low contrast in the texture. IPS has advanced Histogram controls that are both very visual and very effective. **8.6** shows IPS's Histogram screen. Note how I've moved the end point sliders to turn the lackluster texture into one with some snap. One of the best features of Iris Photo Suite's Histogram is the real-time update of the histogram itself. As the sliders are moved, the histogram changes shape instantly, making adjustments very quick and accurate. Shucks, this is even better than Photoshop CS5 where you must release the mouse button before your histogram updates!

8.7 *Designating the Texture as the Base Layer*

8.8 *Opening the Layer in Iris Photo Suite*

So we have a high-resolution texture file with nice contrast at our disposal; let's apply this texture to an image in IPS. To use layers in IPS, we have to honor some app protocol. The first step is to designate our texture as a layer as in **8.7**. Iris Photo Suite has its own terminology for this layer, calling it the "Base Layer." Clicking the Action button (1) in the lower right, choose Layer, and then Set Layer as Base (2).

Now that our nifty texture is set as the Base layer, the next step is to open an image that needs some added texture. **8.8** shows the sequence involved. Granted, the first time you do this, you might feel that you've entered the arena of geekdom. But – and here you'll have to again trust me – after you've loaded images as layers in Iris Photo Suite a couple of times, you'll grasp the logic of the app. It's really pretty easy after a couple dry runs. To get your "target" image (the one that you want texturized) into IPS in **8.8**, first tap the Actions button in the lower right of the screen. Tap Open and navigate to the desired image in one of your libraries. Now, tap Layers to open your layer options.

Now that you've opened the image that needs texture added, you must "Blend with Base" (**8.9**). The word "Blend" is important because one of Iris Photo Suite's powerful features is the ability to exploit Blending Modes. We can't go into a Photoshop lesson on Blending Modes but they do give you a lot of control over how one layer interacts with another.

IPS alerts you that some Blend Modes will affect the image differently depending on which layer is on top and which is on the bottom. We're about to see just that. By default, the Normal blend mode is active once you click OK (in #2). With

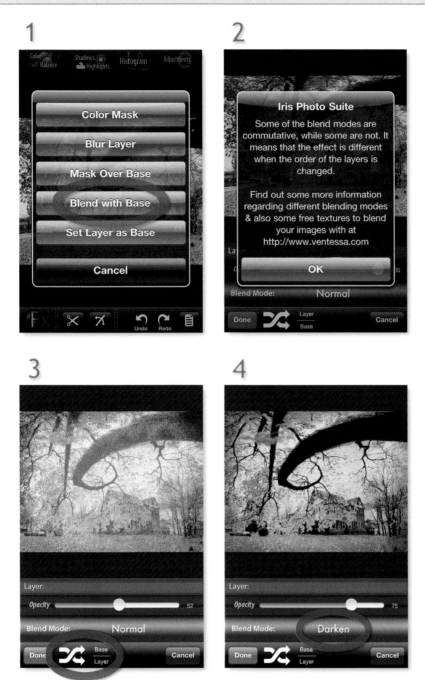

8.9 *Adding Texture to an Image in Iris Photo Suite*

the Opacity slider at 50%, the results are not what we wanted. To honor the advice in screen #2, we're going to inverse the layer order, putting the texture on top with the image on the bottom. The circled crossed-arrows button will do that.

Because we want the texture to only darken the image, choosing Darken as the Blend Mode will work perfectly. The Opacity slider lets us fine-tune the final result so as to apply the texture. And of course a tap on the Done button returns us to a screen where we can save the final image.

8.10 *Layers' Size Options and Adding an Image to a Layer*

8.11 *Layers' Resolution with iPhone 3Gs*

iPhone Artistry

Note: Iris Photo Suite's bag of tricks doesn't end with its layers and blending modes. It has incredible masking talents, too.

A SIMPLE APPROACH TO LAYERS

Hopefully you're not overwhelmed by the Iris Photo Suite approach to layering images, but just in case, let's visit with a couple apps that take a different tack on layering. We mentioned one, Layers, in Chapter 6.

Layers: In the chapter on HDR, the Layers app (www.layersfori-phone.com) proved to be a valuable resource for combining two different exposures from Apple's HDR camera app. Let's look at some of Layers' other fine attributes. In **8.10** the size options are shown. This is the one downside (and, admittedly, a big one) to Layers. On an iPhone 4 and later, you are limited to a maximum canvas of 1MP. If you are disappointed with Layers' resolution options on an iPhone 4 and later, take a gander at your resolution choices on the iPhone 3Gs or earlier in **8.11**.

8.13 explores the layer transparency feature of Layers. This demo image includes four layers, which is actually one less than the maximum of five permitted. Notice that the 2nd layer from the top is selected (by simply tapping on that layer). The blue border indicates the selected layer. This is the layer whose transparency we'll modify. After selecting the layer,

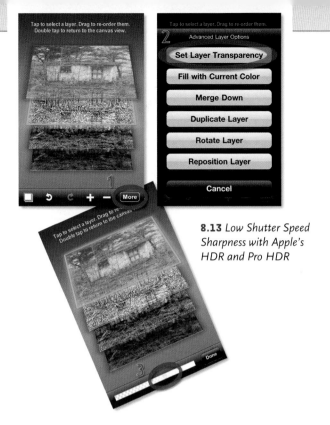

8.13 *Low Shutter Speed Sharpness with Apple's HDR and Pro HDR*

Note: Yep, do the math and you'll discover that the largest canvas you can have with an older-than-iPhone 4-model is 25 MP. Now that's worrisome, isn't it? So much so that, even given Layers' wonderful graphics and features, if you are using an older iPhone, it's best to explore other layering options like Iris Photo Suite, FilterStorm or Juxtaposer. Enough about older iPhones and Layers' limitations; let's look at some of this app's strengths.

tap on the More button in the lower right (1). This takes you to the Advanced Layer Options screen where Set Layer Transparency (2) is the option we want. That brings up the Layer Transparency slider (3) that can be adjusted to taste. Noticed the circled slider (that is very difficult to see). You can adjust the transparency for each layer independently. And of course you can reorder layers by dragging them up or down in the stack.

This just scratches the surface of what Layers can do. We don't have the space to cover its layer erasing, painting, 30-level undo/redo, or myriad brush options. And you'll really be intrigued were I to mention the "export as psd" feature. Yes, you read that right; you can email a layered Photoshop (psd) file that you can indeed open in Photoshop! **8.12** shows this exported psd file in Photoshop. Note that the layer opacity is just as it was set in the Layers app.

If you enjoy layers in Photoshop, you'll love Layers on your iPhone — unless you use an older iPhone that suffers from the Layers resolution handicap.

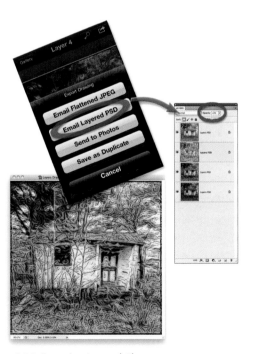

8.12 *Exporting Layered Photoshop (psd) images from Layers*

● ADVANCED MASKING

 PhotoForge2: Here's the mother of all layering apps. I call it advanced masking, because this app surely has the most advanced layering features (though not always the most intuitive) of any app currently available.

PhotoForge2 is the kind of app that you need to play with...a lot. Just as you didn't (or won't) learn Photoshop in one session, odds are you won't grasp all of PhotoForge2's power and complexity over a lunchtime latté at Starbucks. With that caveat fresh in your mind, take a peek at **8.14**. Here I used PhotoForge2's layers to combine a nice border (created in Vintage Scene) with the better, color version of the image. Layers and layer masks were perfect tools for the task.

8.14

Screen 1 shows the PhotoForge2's layer palette with the Vintage Scene border version as the top layer and the better, unbordered version below. In screen 2, I've added a mask to the top layer. Tapping the Edit Mask button (circled in red) will let me paint on the mask to show only the border in the final composite.

PhotoForge2 provides three ways to preview the mask. Tapping the mask icon at the top of the screen (just to the right of the "photoforge" label) will cycle through the ways you can see the mask. Here it's showing (in red) the parts of the layer that will remain visible. The masked border layer (4) now does just what we want by overlaying the border to the layer below.

1

2

3

4

8.15

Juxtaposer: Here's an app that wants to be goofy but has serious-photography potential. Ostensibly a way to put your dog's head on your spouse's body (or vice versa), Juxtaposer is a capable layering app that supports the full resolution of your iPhone and gives you the much-desired ability to both erase parts of a layer (with a mask) and unerase. The first step is to load your base image (**8.15**). If you were working in Photoshop, this would be your Background Layer. In this case I loaded an image from one of the libraries on the iPhone. This is our cat Skeeter (who thankfully does not need a model release).

Once the Base Image is in Place, it's time to load a Top Image from one of the libraries.

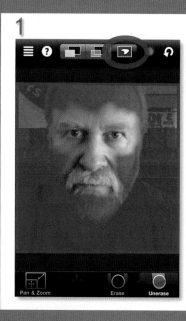
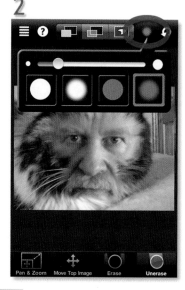

8.16

iPhone Artistry

This image is of me, in a very untypical serious mood. Using our standard reverse-pinch I enlarged the top image (me) to match Skeeter's face better. To help you align images, Juxtaposer gives you a transparent top layer option (the middle button in the top row of mask options). With the Base Layer and Top Layer both in place, it's a simple matter of masking the parts of the top layer that don't work for the composite (**8.16**).

As you mask the top image, you can show the mask material as a red, translucent overlay. This is much like Quick Mask in Photoshop, isn't it? To show the mask like this, tap the red, mask button. With brush options that provide for size, softness and opacity, you can tackle any masking job with precision. Be sure to read Juxtaposer's documentation for additional tips on using the brushes.

And, voila, we have an improved version of Dan and an insulting version of Skeeter! Note the Unerase button (circled) that removes mask material. This ability to fluidly add and subtract from your masks is very powerful.

As you've seen, Juxtaposer has exquisite masking ability. The one thing it doesn't provide is overall layer transparency options. If you need that feature, look to Iris Photo Suite, Layers, or PhotoForge2 instead.

ADJUSTMENT LAYERS

Luminance: Yes, amazing as it sounds, we're now approaching true, Photoshop-like control with adjustment layers, right on our iPhones. The Luminance app takes a different approach to layering. Though lacking local control (for now anyway), Luminance lets us stack effects sequentially. And sweeter yet, we can rearrange the order in which the effects are applied to compare how the effects work in different ways. **8.17** shows some of the adjustment layer attributes of Luminance.

The list of effects I've applied is shown below the image with the most recent adjustment listed at the top (1). You can modify any effect you've applied by expanding the filter. Here I've revealed the sepia controls by

8.17 *Luminance brings Photoshop-like Adjustment Layers to the iPhone.*

tapping the reveal triangle (2). To add another effect, tap the + button (circled in red). A handy on/off switch (circled in blue) does just what you'd think, letting you turn off that adjustment completely. Here I've turned off the Sepia effect.

When you tap the + to add an adjustment layer you see the full range of available Adjustments and Filters (3). The History panel icon (circled) reveals a list of every editing step you've applied to the image (4). This makes it easy to back up to any previous state in your image's workflow. One final bit of Luminance glory is the way the app stores your layered image in its internal library. You can return to an image at any later time to further enhance and edit your photo.

Now we get to the muscular part of iPhone Artistry. In this chapter we put all the pieces together, moving from app to app, using each app for what it does best. We'll use one app for sharpening, another for texturizing, and yet another for a special effect, taking our images right up to being ready to print.

Chapter ⑨ Creative Workflows

Order in the Court (of Image Enhancement)

The order, or sequence, in which we perform our edits and enhancements is important. If you want to add distress to an image but also blur parts to throw emphasis on the subject, then you should apply the blur first and then apply the distress (which is a form of texturizing). If you did these steps in reverse, you'd have sharp distress over one part of the image and blurred texture over another. In a world of artistic license, this might have merit, but odds are it would look strange.

No one approach is appropriate for every image. Let's look at an image I made a couple days ago. This chapter will give you an idea of how I shoot and post-process an image, bringing it gradually and progressively to completion. I promise to take no offense if you find my methods too methodical, too tedious, too anal, or too anything. This is simply the way I work.

Workflow One

Using a single image—as opposed to multiple images—let's look at the workflow for a combination of effects, beginning with the raw capture and walking step-by-step to the final image.

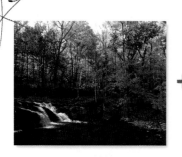 +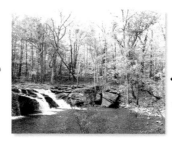

Capture/Exposure: Pro HDR did its thing superbly, combining a dark and light exposure to preserve both the highlight and shadow detail. **9.1** shows the two source exposures and the first HDR image produced by Pro HDR.

=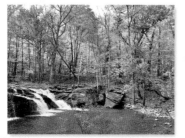

Pro HDR's Two Exposure Melding

9.1

Add Texture: As I go through my personal Steichen phase, texture has become an important piece of my iPhone image-editing scheme. Texture actually hides noise and artifacts, and it helps take us a step away from the antiseptic image perfection that sometimes infects digital photography.

One of the first places to go for texture is Photo-Forge. We mentioned the terrific Curves feature in an earlier chapter, and covered PhotoForge's Watercolor and Oil Painting filters in another chapter, so let's jump in on this image right after those two filters have been applied. The first problem we can tackle is the overall darkness of the image; let's fix that with PhotoWizard (**9.2**).

(1) After applying Watercolor and Oil Painting filters in PhotoForge, the image is a bit too dark. Since we'll be using PhotoWizard for subsequent steps, let's go to that app for a Levels adjustment. The Histogram adjustment is found under the Filters button in the tool bar at the bottom of the screen. (2) Notice how I've dragged the Histogram's midtones slider to the left. This pushes more of the midtones to the right, which lightens the image. Tapping the √ mark in the upper right corner of the Histogram dialog applies the adjustment. (3) With the Histogram change applied, the image looks much better and is ready for the next steps.

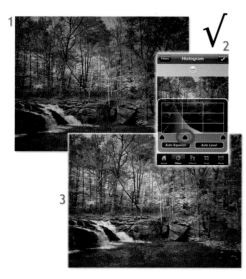

9.2

108

iPhone Artistry

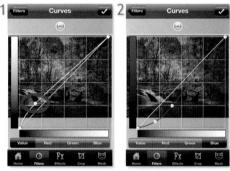

9.3

Note: When you make masked selections in PhotoWizard, the checkerboard represents areas that are NOT selected and will NOT be affected by any filters or effects you apply.

9.4

Adjust Local Tones: The rocks in the lower left are depressingly dark, so let's fix that in PhotoWizard, too. The main reason we're doing this step in PhotoWizard is because of the app's very proficient masking features.

Let's first select those dark rocks in the lower left, and then open up their tonality. **9.3** shows the steps. (1) Tapping the Mask button in the lower right (circled) is a good start. (2) Next, tap the Mask Options button (A) and choose the Magic Wand tool (B). This tool works much like Photoshop's Magic Wand, selecting a range of tones similar to where we click in the image. To make the Magic Wand a little more discriminating (tonally speaking), I'll drag the Threshold slider to the left (C). (3) For more precision in making the selection, zooming-in will help. The two finger reverse pinch makes the zoom easy. Next, as I tap on the image with the Magic Wand, the non-selected areas show up with a checkerboard pattern. (4) Important step: You must inverse your mask by tapping the circled button.

Once we've defined the area, we are ready to apply a curve (**9.4**) in order to brighten that dark area. (1) PhotoWizard considers curves a filter rather than an effect, so tap the Filters button in the bottom tool bar to take you to your list

of options. In this case, we want Curves. I've placed a point on the curve (circled in red) and by raising that point, the tones in the dark rocks are lifted correspondingly—notice the blue cast that accompanies this change. What to do? (2) Select the Blue channel to reduce the blue cast. (3) After tapping the √ button, we see the rocks have better detail.

9.5

With the water properly selected, it's time to apply a PhotoWizard curve to that area to lighten it. **9.6** outlines these steps. (1) A strong curve lightens the water. This curve was shaped with three points (in addition to the default end points). Tap the √ button to apply the curve. (2) This is a good time to save the image, taking care to choose the best resolution. (3) Here's the final image.

Modify Masks: Following our "incremental editing" approach, let's examine the image and decide on the next thing that we don't like about the image. The water in the foreground is too dark for my tastes, so let's use the same sweet PhotoWizard techniques to select the water and then use a curve to lighten it. Many of the steps in **9.5** are familiar, though we will be tossing in a new mask modification. (1) I select the foreground water using the Magic Wand as I did earlier, but try as I might, I couldn't get all the water selected. These unselected areas show up as spots in the checkerboard. The solution? Use another mask tool to fix it. (2) Tap the Mask Options button (circled in red) to select the brush tool, and choose a midsize brush that is appropriate for the water area. (3) Carefully painting over the foreground with the brush, I erase those details from the selection. This way the entire water area will be affected by whatever tonal modification technique I use. (4) Invert the selection by tapping the icon (circled in red).

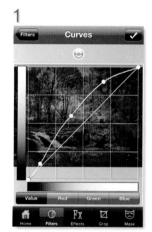

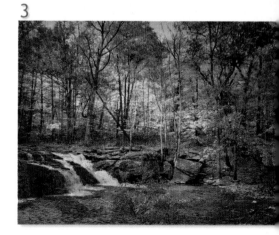

9.6

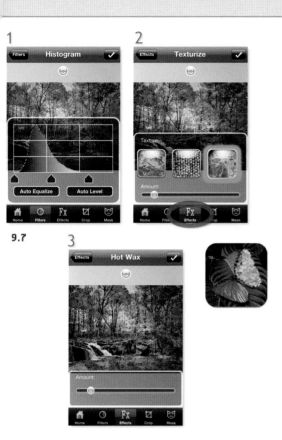

9.7

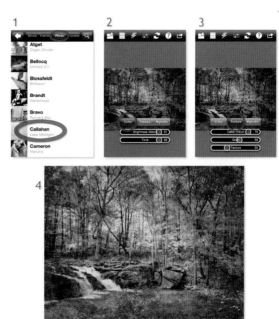

9.8

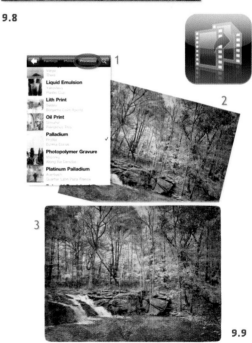

9.9

Add Filters: Let's try a couple new filters. Yes, we're really pouring it on this one but what the heck, that's part of the fun. Learning what works and what doesn't comes from this sort of playful experimentation. **9.7** takes us deeper into PhotoWizard's Fx assortment. After brightening the image with PhotoWizard's Histogram, we finally get to explore the Fx menu where we find Texturize (2). Note that I'm choosing the random texture. The one chosen glows green. We just season with this texture, thus the low amount. (3) Why not add some Hot Wax, too?

9.8 shows some PhotoCopier combinations I want to apply in my image maturation process. PhotoCopier, Using a Harry Callahan Preset: (1) Of the four Art categories, we're working in the Photo category. Harry Callahan's famous "Lake Michigan" image is the image source that will provide color, texture, etc. for our image. (2) After choosing the Callahan preset, we have three places for experimenting: Color, Texture, and Vignette. The lightning bolt in the top tool bar turns the effect off and on so you can preview the results. The slider icon to its right shows and hides the adjustment sliders. (3) The Texture tab provides more control over the preset Detail Match, Grain, and Texture. (4) And here is the final image after saving in Photo Copier.

Let's perform one final Photo Copier effect on this image. The subtle color in **9.8** is pleasant, but let's see what the Processes tab of Photo Copier has to offer in **9.9**. (1) In the Processes tab, I choose Palladium, which is represented by an image by photographer Joe Profita. (2) The default values for Palladium remove the color but leave the image with a slight warm tone. (3) As a last step, I add a border with the Lo-Mob app (www.lo-mob.com).

The 49 images that AutoStitch combined to create the final image.

Workflow Two

Multi-Row Stitching, Texture, and Layers, Oh My!

If stitching becomes a vital part of your iPhone photography workflow, welcome to the club. The spatial vistas that multi-row stitching opens up are a thrill when the technique matches the subject. Let's look at how multi-row stitching, texturizing, colorizing, and a few other techniques sculpted this image.

Stitch the Series: You should be familiar with AutoStitch by now so let's go through the stitching steps quickly. **9.10** illustrates how I selected the series on the iPhone, stitched, cropped and then saved the final image to the Camera Roll. (1) The 49 image series is gathered into AutoStitch from the Camera Roll. (2) The rendering process builds the stitched image like magic. (3) I trim the image to a rectangle—a breeze with the Crop tool. (4) After cropping, the image is ready to be saved to the camera roll.

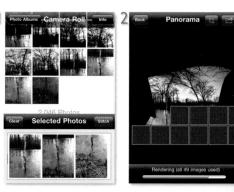

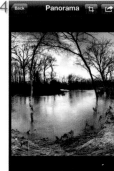

9.10

9.11

Resolution Check

I feel obliged to remind you to check your output resolution in any apps you download and launch for the first time. Remember, some apps have resolution options in the iPhone's Settings while others have options in the app itself. FX Photo Studio is of the latter school, as shown in the image here. (1) The little flower-shaped menu takes you to a screen of options (2), where you can take a photo, load a photo, or access FX Photo Studio's Options. (3) Here you have your save-as resolution choices. Tapping the resolution takes you to (4) this screen, where you can choose from itsy bitsy 320 all the way up to your iPhone's native resolution, which is normally what you want.

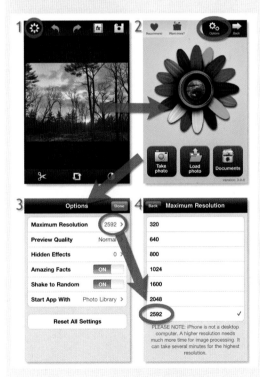

Filter Adjustments: The stitching gives us a perspective unlike anything we could achieve from a single capture along the creek. But the image is ho-hum and too literal for my aesthetic. Let's see if FX Photo Studio can come to the rescue. This app just keeps getting better and better with each free upgrade. If you don't have this app on your iPhone already, get it!

One of my favorite filters in FX Photo Studio is Ancient Canvas. (1) I've selected Ancient Canvas (A) from the Favorites list (B) in **9.11**. (2) Ancient Canvas usually puts the distressed edge effect heavily at the top and lightly at the bottom, but in this case the near-square image confused the app and it placed the heavy texture along the left edge. That would be fine, except the image looks out of balance. Dialing down the effect helps, but I still want to match the effect on the other side. (3) So I flip the image horizontally and then reapply the Ancient Canvas filter. (4) This helpful message informs you that you can apply successive filters to your image to build the look you're after. Good thing, because now we're going for some color!

9.12

Color Adjustment: There are two Rusted Metal filters in FX Photo Studio. Rusted Metal 1 is a streaky mess; Rusted Metal 2 imparts beautiful warmth with more effect placed around the edges of the image—this is the one to use. In **9.12**, you can see Rusted Metal 2 in the Favorites category (1). I take the effect down a bit (2), and then I save this to the camera roll (3) (referred to as the Photo Album in this app).

This image needs a pinch more texture for my vision. No need to leave FX Photo Studio because there's another favorite called Dirty Picture 2 that will work as a final seasoning in this app (**9.13**). I keep Dirty Picture 2 as another favorite (1). Like all the filters in this app, you can adjust the amount of filtration applied to the image by dragging the slider. As we've seen with other filters, as we apply sequential filtration (2) on the iPhone, the image often tends to darken. Here I used the Gamma adjustment (3) to lighten the image before saving it to the camera roll.

9.13

> **Note:** FX Photo Studio's Gamma Adjustment shows up in the lower right corner of the screen (a half moon button) immediately after you apply the filter effect.

Monochromatic Texture: Because one of our goals with this image is to add multiple textures, let's take it into SketchMee to see what kind of handsome crosshatching we can impart to the image.

Uh-oh: Looks like we have a problem (**9.14**). The image doesn't fit properly into SketchMee's image box; SketchMee can only handle a set number of aspect ratios, and our stitched image doesn't conform to any of them. What to do?

9.15

9.16

Cropping or Resizing: We could crop the image to conform to, say, a 4:3 or 1:1 aspect ratio, either of which can work with SketchMee. But, heck, I like the composition and don't really want to eliminate any of the sides or top, something that would happen with a crop. A number of apps let us lock an aspect ratio as we crop; Photo fx has one of the most comprehensive interfaces for any sort of crop you might want to make. But what if we resized the image instead of cropping it? Sure, we might stretch or compress the subject matter depending on how we resize, but a subject like this swollen creek is pretty forgiving anyway. So resize it is, and there's no better app than iResize (**9.15**).

Notice that iResize's Maintain Aspect Ratio is turned off. The resized image should work fine in SketchMee now that it has a nice 1:1 aspect ratio, one of the formats compatible with SketchMee.

Now that we have resized and saved the image, let's bring it into SketchMee again (**9.16**). The square version of our image will work just fine.

1

2

3

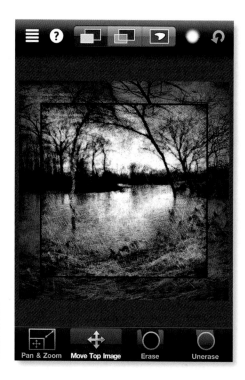

9.17

Sketch Options: We covered the features of SketchMee in chapter 4, but I do want to illustrate how the various sketch options affect the final image produced by SketchMee.

In **9.17**, I've applied three slightly different variables to the image. (1) The Hard setting for the tip of the chalk makes the texture a bit too harsh. (2) Dropping the tip hardness to Balanced softens the sketch effect just enough to make it appealing. (3) I changed the Paper setting to Grainy to see how it would affect the texture. It does add some smudginess to the highlights in the image.

Because of the way we're going add this textured image to the color version, extra highlight detail from the Grainy Paper setting doesn't matter, so I reset it to Plain. When you have the texture looking good in the preview, save this version of the image to the camera roll.

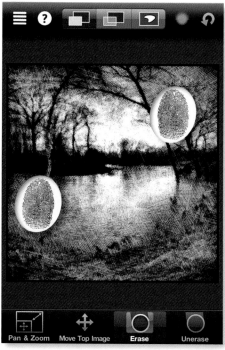

9.18

Layering: One of the virtues of Juxtaposer is that once we load two images (one as the bottom layer and one as the top layer), we can erase and—just as importantly—reveal parts of the top layer. We also have fine control over the brush size, softness, and opacity.

Take a look at **9.18**. On the left is the screen after loading the second image, which is the textured image we just saved from SketchMee. It is clearly smaller than the color version of the swollen creek. Juxtaposer does this as a favor, assuming you are bringing in an image from which you just want to use a small section. Here, however, we want our color version and sketched version to align perfectly so we can apply the texture in perfect registration. Juxtaposer doesn't let us down. Seems the developers gave this app twin personalities. To align the top image with the bottom one, tap with two fingers as shown in the right screen in **9.18**. Presto! The top image resizes to match the bottom image and we have perfect alignment.

Now that the images are aligned, it's time to start erasing the top, textured layer. The goal is to have just some of the texture appear on the image. One of Juxtaposer's limitations is that it has no provision to control layer opacity globally, so we can't adjust the overall effect of the top layer. But for images like this, I really like the organic, non-linear way the texture is erased away with the brush. It gives a more natural and, dare I say, artistic feel to the texture addition.

On the left panel of **9.19** you see the brush options. I've chosen the transparent brush in a medium size with a soft edge. It's very rare that I use either the hard brush or the full opacity version of the brush. By using a soft, semi-opaque brush, I can concentrate on just one variable, changing the size as I erase or reveal parts of the top layer. The right panel in **9.19** shows the image with just the right amount of texture remaining.

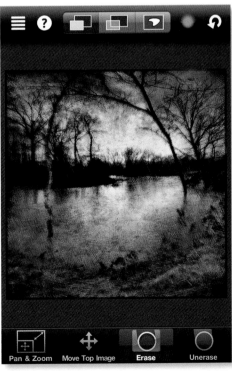

9.19

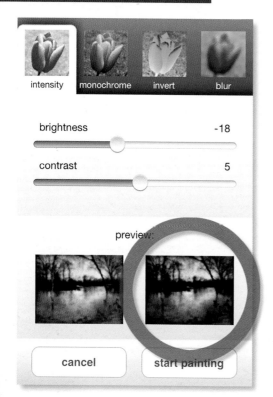

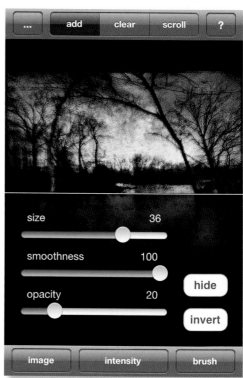

9.20

Burning and/or Dodging: The image is nearly complete. The one last thing I'd like to do is darken parts of the foreground, much like we'd "burn" areas under an enlarger. And what is our weapon of choice for this area control? It's Effect Touch.

9.20 shows the settings that will darken the image. The circled preview shows what the effect would look like were it applied to the entire image. Of course, that's not what we want; we have fine brush control that lets us paint in the darkening. The right panel in **9.20** shows the brush size, smoothness, and opacity that I've chosen to darken the foreground.

That does it! And darn if it isn't nice. **9.21** shows the finished version, glowing with spatial abundance from the stitching in AutoStitch, full of rich color and distress from FX Photo Studio's multiple filters, textually rich thanks to SketchMee, all combined with layers in Juxtaposer, and finally some local tonal tweaks were accomplished with Effect Touch.

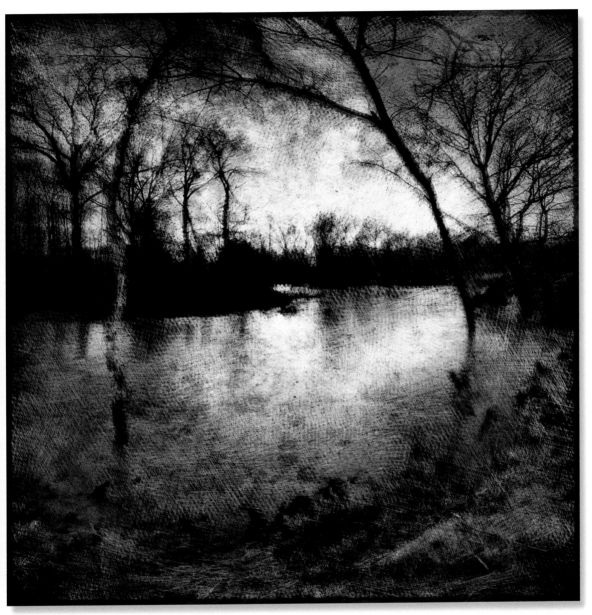

9.21

9.22

Workflow Three

Adding Depth to Tree Figure

Who doesn't like a forest face that's sure to scare the neighbor kids? Actually, our neighbors' kids are great sports who love this sort of thing, but that won't discourage us for a minute. Let's look over the steps used on this image, paying particular attention to the order of adjustments and enhancements.

Contrast: Pro HDR did a great job of handling the contrast in the original scene; I used Auto Mode for this image (**9.22**). The image was saved back into the camera roll after the HDR processing.

Sharpening: For sharpening, it's hard to beat the control of PhotoWizard (**9.23**). With controls similar to those in Photoshop's Unsharp Mask, just the right amount of sharpening could be applied. And here again, after sharpening the image it was saved into the Camera Roll.

9.23

Filters **Unsharp Mask** ✓

Radius:

Amount:

Threshold:

🏠 Home ◑ Filters Fx Effects ✄ Crop 😺 Mask

9.24

Retouching: Now it's time to get rid of those nasty screws that are showing. In case you hadn't guessed, this is not a real face on the tree but a rubbery resin facsimile that is quite realistic. But alas, it is held on by four screws, three of which are visible in this shot. The perfect app to retouch these is TouchRetouch! **9.24** shows a screw head that I've highlighted with Touch Retouch's brush tool. After that it's a one-click deal to seamlessly remove the three screw heads from the face.

Depth of Field: To emphasize the tree crea-ture, let's use TiltShift to blur the background and left edge. This app gives us control over the shape and size of the parts of our image that should remain sharp. And TiltShift pro-vides control over the amount of blur applied to the out of focus areas.

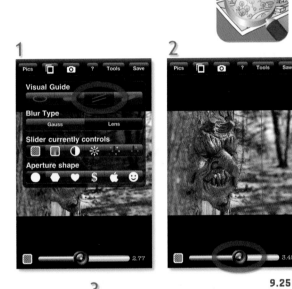

9.25

For this kind of shot (**9.25**) it makes sense to keep a vertical area sharp, leaving the sharpness gradually fade off to the sides. The linear tool (1) works well for this. The size of the sharp area can be moved, resized and rotated with your fingers. Here I've positioned it over the tree face. The amount of blur is adjusted with the slider circled in red (2). Tapping the Save button (in the upper right) presents you with two resolution choices. We love resolution so the original 5MP of the iPhone 4 is circled (3).

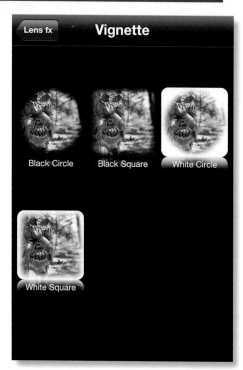

9.26

9.27

Vignetting: Ok, we have created a sense of depth in the image by selectively blurring areas around the face. But those background areas are too light and distract from the lovely features on the Tree Man. There are lots of apps that add a vignette effect, but few of them offer the control of Photo fx.

All of our vignette methods are shown in **9.26**. For this image, we're using the Black Circle. The Black Square could probably work too but you'll see below how we manipulate the shape and size of the Black Circle to get just the right darkening.

In **9.27** several of Photo fx's vignette parameters need to be adjusted. When first selected, the Black Circle vignette will appear with the amount at 100% and the softness set at 50%. Both of these settings are overdramatic for most images. Another problem is that the vignette is, by default, centered within the image area. We need to move the vignette so it's centered over the Tree Man's face. Tapping the bull's-eye icon in the bottom of screen (1) presents the vignette position tool as a center dot (the center of the vignette) and dotted outline (the outer rim of the vignette) (2). We use these two features to change position and size of the vignette. To move the vignette within the image area, tap, hold and drag the black center dot. To make the vignette larger or smaller, tap and hold the dotted perimeter and drag it in our out, depending on whether you want to make the area that's not vignetted larger or smaller. Remember, it's the area outside of the circle that gets darker. In (2) I'm dragging the perimeter out to make the vignette larger.

When you have the size and position set, then it's time to tweak the softness and amount (3). In most cases you will want the softness adjusted closer to 100%. This is another of those adjustments that doesn't have a right or wrong way to do it. If the final results look good, you did it correctly.

Burning and/or Dodging: That vignette worked great to darken the background and even the left side of the tree but there is a light area to the right of the Tree Man's face that just isn't working. After all, one of our goals is to guide the viewer's eye around our image. If we orchestrate those eye movements properly, we have a better chance of eliciting the appropriate emotional response to the image. Let's see how we can use Photo fx to darken ("burn" if you will, for the classic darkroom readers) that area beside Tree Man's face. **9.28** has three panels that help move us in that direction. Here's the image after doing the vignette (1). All is well except for that light area we mentioned. We could dance to another app to darken that area but let's instead use Photo fx's very cool masking to accomplish that. Before proceeding, you might want to save the image. Even though each Save As adds another space-eating version to the camera roll, it's cheap insurance in case the app crashes or some other event dumps on your digital life unexpectedly.

Now this is where Tiffen could improve the terminology in the app. The "Add Layer" selection (2) should really read "Add Effect." There are no actual layers in Photo fx, so their way to designate how you add a sequential adjustment is misleading.

Photo fx's Levels are a good way to change the tonality (3). Curves would be better, but we don't (yet) have curves in this app. Besides, the task at hand—darkening the area to the right of Tree Man's face—is not that difficult from a tonality perspective. It does require local control and Photo fx excels at their version of masking. Notice that my levels adjustment is making the entire image dark. Don't worry; we'll limit that darkening to the desired area in a moment; for now I'm using levels to darken the image, watching how dark I'm making that area next to the face. Before we move on to our next illustration for this image, take notice of the circled paintbrush at the bottom of (3) in **9.28**. Tapping this paintbrush takes us into Photo fx's mask mode. So fasten your seat belts.

9.28

9.29

Masking in Photo fx: It's a good thing Photo fx has a comprehensive Help File built into the app itself. Without it, I'd have been lost when trying to learn all the features. That little "?" in the right side of the tool bar will bring up a context-sensitive help screen. That means the help will be geared toward the screen and tools you're using at that time. The first time you use masking in this app, tap that help button and read all you can about how you use the masking features. You'll be glad you did.

Let's take this step-by-step. **9.29** includes some important information so pay attention! When you first tap the mask icon (the paintbrush), Photo fx assumes you want the effect you just devised (the levels adjustment) to apply to the entire image. That's why the image looks so dark here. This is fine if you want the majority of the image affected, but we only want it in that area beside Tree Man's face. Rather than paint out all the effect except for that one area, it makes more sense to

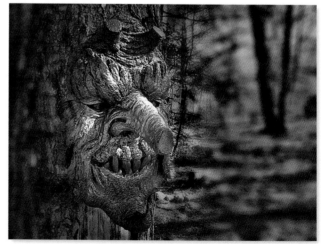

9.30

invert our mask so we instead "paint-in" the effect on that small area. Tap the circled "invert" button in the toolbar to invert the selection (1). The image looks normal, and all that's left is to choose an appropriate brush size, softness, and opacity. To bring up your brush options, click the brush button (2). Start with a larger brush and work to a smaller one.

9.30 walks through the final steps in tweaking the image tonality. Notice the size, softness, and opacity of the brush (1). Photo fx does a great job of clearly showing a preview of the brush in a white box. (Believe me, not all apps are so courteous in this regard.) This larger brush will be perfect for painting in the darkening Levels adjustment we designed a few steps ago. In some ways, what we're doing is a bit like painting with the History brush in Photoshop. The brush size, softness and opacity share importance equally. Too much or too little of any one attribute will make for a noticeable darkening of the area. But having said that, a bit of sound advice is that you should favor softer brushes over hard ones; they are much more forgiving as you paint-in your effect.

I've moved to a smaller brush (2) but one with more softness and less opacity. This brush worked better as I painted-in the final darkening effect to the right of Tree Man's face. Notice how that light area is darker than the version in **9.29**.

Stylizing: As you might have guessed, we're not finished yet. Adding some aging effects to this image will complement the subject matter. Back in the Enhancements chapter you learned how to use VintageScene to create a texture that was then applied to an image. Now we're going to do something different, using VintageScene directly on an image to construct its mood into one more "vintage."

9.31 takes place in VintageScene. When you first launch VintageScene and load an image that you'd like to stylize, vintage scene will apply one of their built-in presets. Odds are you won't be satisfied with this random look, so let's learn how to explore VintageScene's options to get the look you want. In this case the light, yellow look doesn't fit the image. To explore other presets that are included in the app (and thoses you add as time goes on), tap on the icon circled in the tool bar (1).

9.31

9.32

We're moving in the right direction. In **9.32**, Image Age refers to how much of the color is applied (1). By sliding down the Image Age, the amount of brown applied to the image is reduced. Fade Out reduces the overall filter effect, though never entirely. Image Strength lets more of the original image show through, and I have no idea what Outline Strength does. (I've never seen it change anything in my images but that might be my problem.) Tapping OK takes us to the next screen.

The border texture effect is still too strong. Tapping the "Brush 3" button (2) will let us choose a different border and amount. And what a selection of borders we have! Figure **9.33** displays nine of the 63 borders included with VintageScene.

Here's the border we're going to use (1) to give a lighter, vintage feeling to the edges. After clicking OK, we see a preview with the new border. One last step: saving this group of parameters as a preset so we can apply them again on our future images. Tapping the Save button (2) will let us do that.

Figure **9.33** wraps it all up! Tapping Save Preset seems like the obvious way to go (1). This same menu provides the Save to Camera Roll option. Here you get to name your preset. Choose a name that will jog your memory a bit (2). (VintageScene saves a thumbnail as well, so you have a visual reminder, too.) And here's the final image in all its glory. Notice the nice border that VintageScene added. Note that sometimes the full border effect isn't apparent until you save the image.

9.33

iPhone Artistry

Workflow Four

Pano Stitching, Tilt-Shift Effects, Distress and Hue Shifting

Let's tackle something a bit different this time. It's another stitching job, but this time a single row.

Combining HDR Exposures: There are only four different images in this group, but each image has is a light and dark version. You should know what that means! I shot this series with an iPhone 3GS that has the touch-to-focus feature. Our much admired Pro HDR did not have an "Auto HDR" feature when I shot this, so I made two different exposures—one light and one dark—by focusing on different brightness areas in the scene. This technique still works if you are using the current Pro HDR's "Manual HDR" or "Library HDR" methods. I am using the Library HDR method as you see in **9.34**. I loaded each set of two images by tapping Library HDR (1) and selecting the dark and light images (Pro HDR will tell you to load the dark image first). Pro HDR merges the two images (2). After tweaking the sliders to get the best tonality and color, I save the image to the camera roll (3).

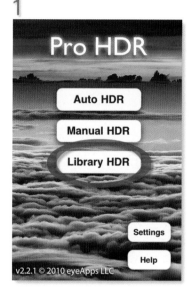

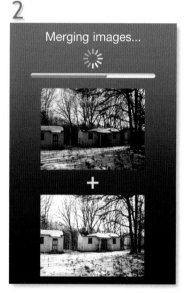

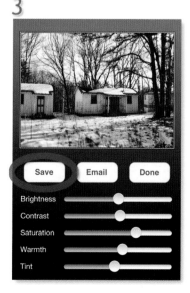

9.34

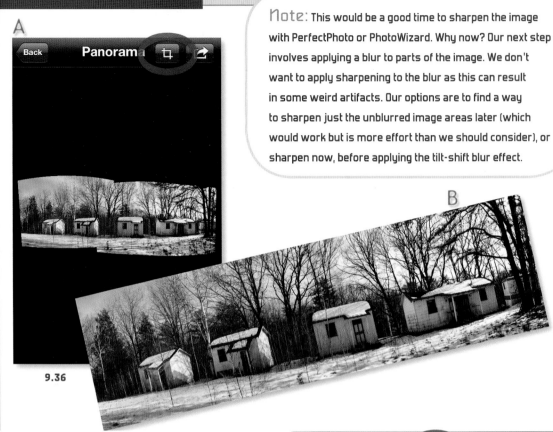

A

B

9.36

note: This would be a good time to sharpen the image with PerfectPhoto or PhotoWizard. Why now? Our next step involves applying a blur to parts of the image. We don't want to apply sharpening to the blur as this can result in some weird artifacts. Our options are to find a way to sharpen just the unblurred image areas later (which would work but is more effort than we should consider), or sharpen now, before applying the tilt-shift blur effect.

Stitching the Single Row Pano: After performing the HDR on the four sets of images, I loaded them into AutoStitch where the panorama was created. **9.36** shows the final steps. After AutoStitch combines the images, you must crop off the scalloped edges (well, unless for some wacky artistic reason you like the crooked edges). The cropped image was then saved to the Camera Roll.

Warping: The pano was starting to come together but the curvature along the bottom edge was worrisome. Even though it's a "natural" effect in some pano building endeavors (the pivoting lens panorama camera are famous for this type of curvature), that doesn't mean it's good looking. Let's see if we can straighten those bent lower corners.

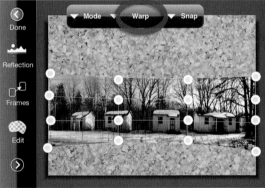

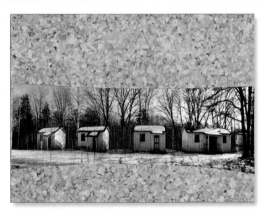

9.37

There aren't many apps that let us perform Photoshop-like warp transformations but it only takes one good one to get the job done. Mirage – Photo Studio boasts a long list of unique features but its perspective and warp transformations are rare in the app world. **9.37** takes us through the paces of warping this pano to fix the curved edges.

The Mode Menu is where Mirage's warping power resides. Choosing Warp gives you access to control points that you can move to any position needed. There are some warping presets under the Warp menu (circled in **9.37**) but in this case I manually shifted the four corner controls to reduce that curvature. Notice in the bottom panel that the horizon is now straight instead of bowed up on the ends.

9.38

Cropping the Pano: Crop for Free is one of my favorite cropping utilities because of its no-nonsense interface and easy to grab cropping handles. Much to my chagrin, Crop for Free would not let me drag the cropping corners down far enough to eliminate the cork canvas area from Mirage (see **9.38**). Notice the edge that I could not crop out in Crop for Free. The cropping handles would not move close enough on this pano (1). This was the first time Crop for Free ever failed me.

Going to Photogene instead (2), the corner crop handles were easy to drag and move to just the right position. I even went a step further and cropped off a bit of the left edge where there was too much space next to the end cabin. App dance step successful!

9.39

Adding Tilt-Shift Effect: The pano needs something else—let's apply a tilt-shift effect so it looks like we used a view camera and applied a reverse tilt to the lens. TiltShift is just the app for this effect.

TiltShift has two ways of displaying on screen the area that will remain sharp as you apply blur to parts of the image. **9.39** shows these two methods. The solid red area (circled in green) is shown on the pano image in the top panel. The two perimeter lines (circled in red) is the method I prefer, and the effect is displayed in the bottom panel. The lines don't obscure as much of your image as you change the shape and/or position of the protected area. Notice how both the top of the image (trees and sky) and the foreground snow are nicely blurred. Of course, the intensity of the blur in those areas can be adjusted via the slider at the bottom of the screen.

9.40

Adjusting Exposure: You might feel different but the image is looking a bit dark for my taste. Since FilterStorm is our next stop anyway, the first step there will be to apply an overall curve to open the darker midtones, as in **9.40.** Notice the Apply button is highlighted. This button will apply the curve to the entire image. The "Apply with Mask" button opens the door to local adjustments, as we'll do in a moment.

Burning and/or Dodging: Next, let's darken the top and bottom of the image; this will help keep the viewers' eye from wondering out of the image. FilterStorm can do the job again for these local area tone changes too, but this time we'll use that "Apply with Mask" button.

9.41 shows the curve that darkens the image (1). Notice that I've pulled down the white point (indicated by red arrow). This will darken any bright highlights in the affected areas. When the curve is darkening the image correctly (on the entire image at this stage, which is considered a global adjustment), I tap the Apply with Mask button in the lower right.

1
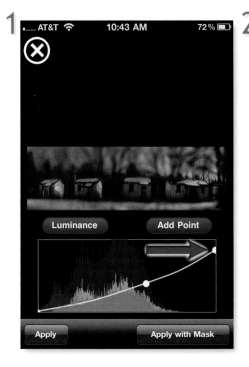

2
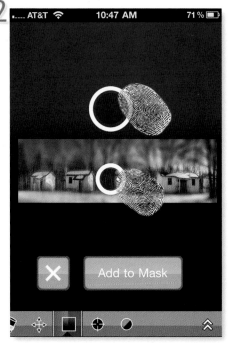

9.41

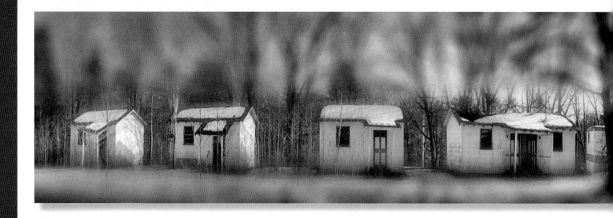

There are different masking tools in the tool bar at the bottom of the screen. I've chosen the gradient tool; you can tell by its darker gray color in the tool bar. Those two circles over the image are FilterStorm's way of showing the start and end of the gradient tool. Just as in Photoshop, you start the gradient where you want the effect to be least applied (in FilterStorm that's the smaller circle), and end the gradient where you want the filter fully applied (the larger circle). You position these with two fingers, as indicated (2). To complete the top edge burn, I tapped the Add to Mask button. We won't be adding to the mask, so tapping the √ will apply the curve effect to the top of the image. These same steps are repeated with the gradient drawn on the bottom of the image to darken the foreground.

Let's take a look at the entire image at this point in **9.42**. The FilterStorm gradients worked well on the top and bottom of the image, but there are a few areas in the white cabins that are too bright, altering the mood of the image.

Fine Tuning: FilterStorm does more than gradients. We can paint-in a curve effect locally, also. In **9.43**, I'm using FilterStorm's mask brush to paint in the curve's darkening effect. First, we design a curve that provides the image darkening. Remember, as you move the curve points, you will see the effect applied to the entire image. Not to worry, as your next steps localize the effect to just those areas desired.
The size, softness and opacity are important. Every image and every area will have it's own need for specific brush specs so practice is the best advice. With the mask brush chosen, I'm painting the curve darkening effect over the bright cabin areas.

Shifting Color Temperature: The "real" color of the panorama is unexciting so let's see if we can add some mood, again with FilterStorm. In **9.44,** we see FilterStorm's Hue/ Saturation control makes it easy to strip out all the color (1). I used FilterStorm's Color

2

Note: Remember, when applying brush-in effects, it's better to err in favor of low opacity and high softness. You can fix these easier than if you screw-up with a brush that has too much opacity and/or too little softness. And if you get completely out of control, you can tap the X button to cancel out of your mask painting operation.

3

9.43

Temperature adjustment to shift the color to the cool end of the spectrum. The color sampler targets the base color that will be shifted cooler or warmer by the slider (2).

Adding Image Elements: I photographed this line of abandoned cabins on a day when a blue moon was to occur that evening. Seems only fitting that I make the image blue and insert a moon. Let's use an app that is a master of local control: Effect Touch.

Note: Don't forget to save your image after each editing step, especially if you are jumping from one app to another. You can always trash any extra versions of the image that lurk in your camera roll.

1

2

3

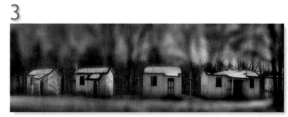

9.44

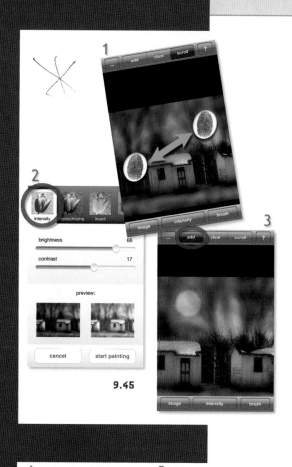

9.45

iPhone Artistry

9.46

Effect Touch's scroll button lets us zoom in with a reverse pinch (see **9.45**). Because we're working on such a small area, it's better to enlarge the image this way to work with more precision (1).

For the moon, the effect should be brighter and a bit higher in contrast, so I'm using the Intensity adjustment (2). Using a brush of appropriate size, it's a simple matter to paint the spot in the sky that looks like a moon (3).

Adding Character: Does anyone else think this image is a bit too sterile (in an aesthetic way, not re-productive)? Let's fix that in FX Photo Studio. **9.46** demonstrates a bit of experimentation, just for fun.

The Burnt Paper filter actually looks cool (1), though it overrides our nice blue color and is also too heavy on the incinerated edge effect. Oh well, it was fun for a moment. Dirty Picture 2 has the right amount of distress and doesn't change the overall tone of the image (2). The Amount slider provides a way to dial in just the right amount of distress. After tapping Apply, I think the image looks too dark, so the next step is to use FX Photo Studio's effective Gamma adjustment. Take a look at the image as it appears now in **9.47** after saving it to the camera roll.

Let's go one final step further. Our good friend Pic Grunger can help us bring this project to fruition. Scrolling through Pic Grunger's list of Effects in **9.48**, the Weathered effect looked most appropriate (1). The next decision is one called "Style." I liked several in the short list but Gig looked best for this image (2). Lastly, vary the Strength until just the right amount of grunge is applied to the image (3). Oh yeah!

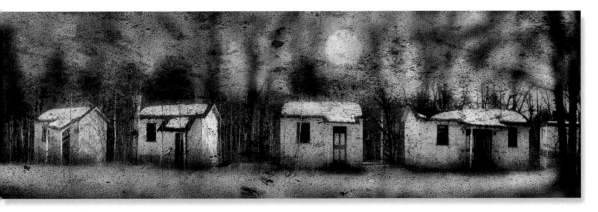

9.47

9.48

Finished at Last: Yep, that brings us to a happy ending. Doesn't the final image in figure **9.49** look just terrific!

There are more apps becoming available every day, bringing even more ways to capture and stylize your images. But if you've read this entire book and have tried some of the techniques with your own images, you're better prepared than ever to handle whatever new apps, techniques, and hardware come your way. Now it's time to go outside and make some images!

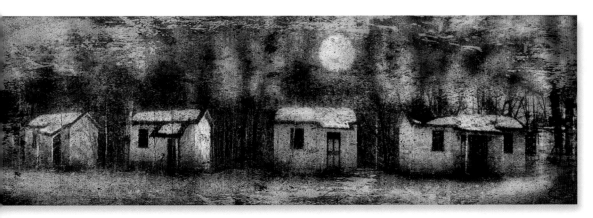

9

iPhone Models and their Specs

iPhone Model	Date Introduced	Camera Resolution	Other Camera Features	LCD size a Resolutior
Apple iPhone (original "Sil verback")	1/9/2007	2.0 MP Still 1200 x 1600 pixels	Fixed Focus	3.5" 320 x 480 at 163ppi
iPhone 3G	6/9/2008	Same as Original iPhone	Fixed Focus	Same as Origi
iPhone 3GS	6/8/2009	3 MP Still (1536 x 2048 pixels) Video: 480 x 640 pixels	Auto Focus, Macro and Touch-to-Focus. Video: 640 x 480 pixels at 30fps	Video: 640 x 4 pixels at 30fps
Phone 4	6/7/2010	5 MP (1936 x 2592 pixels) Backside il luminated sen sor, Front-facing camera with 480 x 640 resolution, Video: 720p at 30fps	LED Flash (and for low-light focusing), 5X Digital Zoom, HDR added with iOS 4.1	3.5" 640 x 960 at 326ppi Retina Display
iPhone 4s	10/14/2011	8 MP (2448 x 3264 pixels) f-2.4 lens, Front-facing camera with 480x640 resolution, Video: 1080 @ 30 FPS	5-element lens, larger, improved sensor, face detection (stills only)	Same as iPhone 4

Processor Speed	Onboard RAM	Storage	Networks	Bluetooth?	Other Neat Features
412 MHz	128 MB	4 GB, 8 GB, 16 GB (4 GB Discontinued Sept. 2007; 16 GB Introduced Feb. 2008	Wi-Fi (802.11b/g), Edge		Accelerometer to detect Landscape or Portrait Orientation
Same as Original	128 MB	8 GB and 16 GB (White iPhone in 16 GB Only) 8 GB, 16 GB and 32 GB	Wi-Fi (802.11b/g), Edge and 3G	2.0+EDR	Accelerometer, Real GPS and Extended Battery Life
600 MHz	256 MB	8 GB, 16 GB and 32 GB	Same as 3G	2.1+EDR	Added Voice-Over and Oleo phobic (oil repellent) Coating on LCD, A faster Grapics Processor is added
1Ghz A4 Processor	512 MB	16 or 32GB	Same as 3G and 3GS	Same as 3GS	All features of 3 GS plus Video Conferencing with other Wi-Fi connected iPhone 4's, Back-Illuminated camera CCD for reduced noise and better low-light performance, 3-axis gyroscope
Dual Core A5 nsor (800 Ghz	Same as iPhone 4	16, 32 or 64GB	Same as 4 for most network protocols, supports AT&T's faster HSDPA 14.4 network	Bluetooth 4.0	All features of 4S plus 1080 Video Recording with Image Stabilization, better low light performance, advanced hybrid infrared filter delivers truer colors, AirPlay and Video Mirroring,

iPhone Shutter Speeds, Apertures & Sensor Size

iPhone Model	Focal Length	Aperture	Range of Shutter Speeds	ISO Range	Sensor Size, MP and Type	Other Camera Features
Apple iPhone (original "Silver-back")	3.85 mm, Equivalent to approx. 37 mm on a full-size sensor DSLR	2.8	1/5 sec. to xxx			
iPhone 3G	Same as Original iPhone	2.8				
iPhone 3Gs	Same as 3G	2.8			1/4" 3.1 MP CMOS	White Balance Support
iPhone 4	3.85 mm, equivalent to approx. 28mm on a full-size sensor DSLR	2.8	1/15 sec. to 1/2000 (approx.) (extended if 3rd party apps are used; see chapter xxx)	80-1,000	1/3.2" Backside Illuminated CMOS	White Balance Support Note: for HD Video, the iPhone 4 appears to use the center 1280x720 of the sensor, resulting in a longer focal length for video.
iPhone 4s	4.28 mm, equivalent to appro. 28mm on full-size sensor DSLR	2.4	1/15 sec. to 1/4000 sec. (approx.)	64-800	Slightly larger than iPhone 4	1080P HD Video with Stabilization hybrid infrared filter for better color rendition face detection (stills only)

iPhone Artistry

App Appendix

ArtStudio 59

AutoStitch 65–67, 112, 118, 128

Bracket Mode 80–81

ClearCam 34–35

Crop for Free 129

Effect Touch 118, 133–134

FilterStorm 46, 61, 131–133

FrontView 45

FX Photo Studio 53, 113–114, 134

GorillaCam 30

Hipstamatic 50

History of Cameras (HOC) 52

iResize 47, 115

Iris Photo Suite (IPS) 40, 95, 96,

Juxtaposer 101, 103–104, 117

Liquid Scale 88–89

lo-mob 111

Luminance 105

Mirage-Photo Studio 43, 60, 129

MobileMonet 60

PaintBook 60

Perfect Photo 41, 43, 90, 128

PhotoWizard Editor 38, 91, 108–111, 120

PhotoCopier 59, 111

PhotoForge 38, 54, 108

PhotoForge2 38, 102, 103

Photo fx 44–45, 85, 122–125

Photogene 40, 129

PhotoSize 41, 97

ProCamera 31–33

SketchMee 55–57, 115, 116

Slit-Scan Camera 50

SwankoLab 51

TiltShift 59, 121, 130

Tiny Planet 61

ToonPAINT 58, 95

TouchRetouch 86–87, 121

VintageScene 54, 96, 125–126, 135